To Margaret
in loving memory of your
husband Willie
from your friends at the
Art Gallery. aNd YolPet
Jove.

NO MORE
WISHY-WASHY
WATERCOLOR

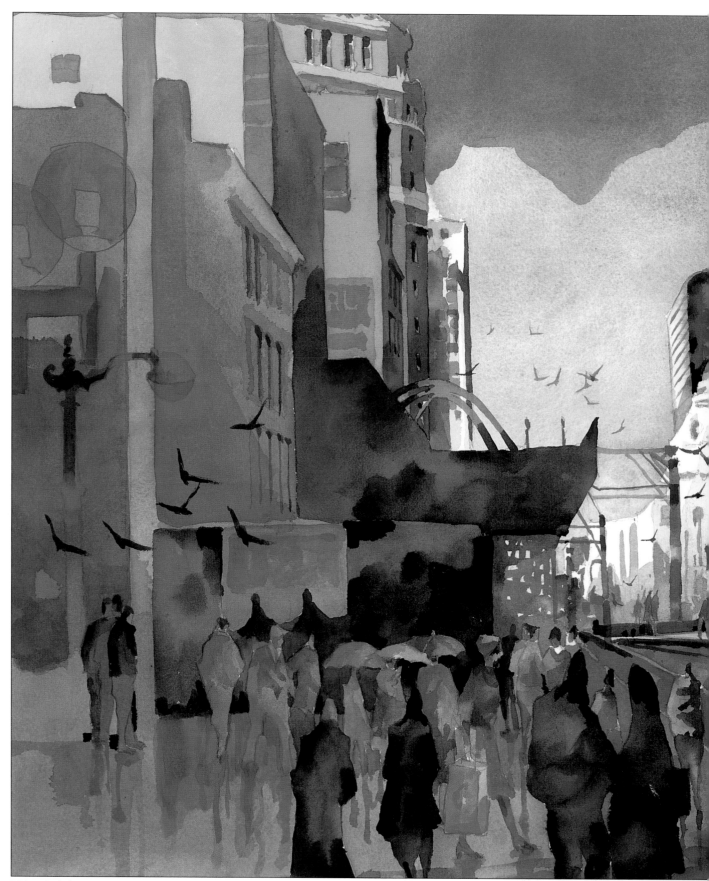

Urban Kaleidoscope
22″ × 30″
55.9cm × 76.2cm

NO MORE
WISHY-WASHY
WATERCOLOR

MARGARET M. MARTIN

NORTH LIGHT BOOKS
CINCINNATI, OHIO

ABOUT THE AUTHOR

Margaret M. Martin is a native of Buffalo, New York, where she resides and maintains a studio building. She graduated from Boston University with a B.F.A. in Advertising Design, which led to a career as a graphic designer and art director for many years.

An intense desire to learn more about painting in the watercolor medium progressed to participating in workshop sessions taught by master watercolor artists in inspiring international locations. Now an artist and teacher of the transparent watercolor medium, she is a guest instructor for workshop sessions as well as an invited juror for national and regional exhibitions.

Martin has been the recipient of many national awards, including recognition from the American Watercolor Society, The National Arts Club, the Midwest Watercolor Society, the Salmagundi Club, the Adirondacks National Exhibition of American Watercolor, the Catharine Lorillard Wolfe Art Club, the Knickerbocker Artists and others.

Inspiration for her painting concepts comes from what she experiences and knows. The color and vigor of flowers are staged in her handsome gardens for direct involvement and feeling. Living and working in the city for most of her life has allowed her a profound response to light and shadow patterns on architecture and waterfront activity.

A Signature Member of the American Watercolor Society, the National Watercolor Society and the Midwest Watercolor Society, her paintings are included in numerous public, corporate and private collections including the Taiwan Art Institute in Taipei, Taiwan.

Her works have been featured in other North Light Books, including *Splash 1*, *Splash 2*, *Painting the Effects of Weather*, *Painting With the White of Your Paper*, *The Best of Flower Painting*, *How to Paint Trees, Foliage and Flowers* and other publications.

"I try to digest the atmosphere and sparkling light of things that I relate to, and translate that feeling into fresh, vital, transparent watercolor paintings."

No More Wishy-Washy Watercolor. Copyright © 1999 by Margaret M. Martin. Manufactured in China. All rights reserved. No part of this book may be reproduced in any form or by any electronic or mechanical means including information storage and retrieval systems without permission in writing from the publisher, except by a reviewer, who may quote brief passages in a review. Published by North Light Books, an imprint of F&W Publications, Inc., 1507 Dana Avenue, Cincinnati, Ohio 45207. (800) 289-0963. First Edition.

Other fine North Light Books are available from your local bookstore or art supply store, or direct from the publisher.

03 02 01 00 99 5 4 3 2 1

Library of Congress Cataloging-in-Publication Data

Martin, Margaret M.
 No more wishy-washy watercolor / by Margaret M. Martin.—1st ed.
 p. cm.
Includes index.
ISBN 0-89134-876-X (hardcover)
 1. Watercolor painting—Technique. I. Title
ND2420.M365 1999 98-39799
 CIP

Edited by Joyce Dolan
Production edited by Michelle Howry
Designed by Angela Lennert Wilcox

DEDICATION

I dedicate this book with love and appreciation to my mother and father.

My father, an architect, demonstrated by example a discipline and passion for his work. He showed me that one must develop an inner drive to achieve excellence.

My mother, having a fine arts background, radiated an optimistic art spirit of excellence and good taste. She encouraged me to evolve and adhere to independent convictions.

ACKNOWLEDGMENTS

Thank you . . .

To my immediate family who know and understand so well.

To the master artists who shared their extensive art knowledge on international watercolor workshop sessions.

To those artists in the Buffalo area (you know who you are!) who kept asking many years ago, "When are the classes beginning?" Your constant nudging finally encouraged me to begin sharing my love for the watercolor medium.

To Mary Barry for her loyal support, friendship and faithfulness to professional integrity.

To the many collectors who offer encouragement and support through purchase of original paintings.

This book project has involved a number of people.

Thank you . . .

To the Buffalo Photo staff for their reassurance and help in solving one photographic dilemma after another.

To Marcia Pelone, a court reporter by profession, who handled my manuscript typing and word processing. Her professionalism and calm manner was most reassuring.

To my editors—Rachel Wolf, who first presented the challenge to write a book; and Joyce Dolan, who was always available throughout the project to inject confidence and professional guidance. You have both earned my highest admiration and respect. Thank you also to production editor Michelle Howry and designer Angela Lennert Wilcox for their part in the creation of this book.

Table of Contents

Materials, 11

Control the Medium, 17

Washes

Strokes

Edges

Celebrate Bigness, 23

Think Big! Think Abstractly!

Positive vs. Negative

Use the Edges of Your Paper

Design Big Areas to Highlight Your Center of
 Interest

Celebrate Bigness—DEMONSTRATION

Introduction, 8

Conclusion, 126

Index, 128

Create Drama With Value, 45

What is Value?

Value Chart

Build a Value Sketch

Simplify the Value Dilemma—
 Use One Color

Identify and Weave the Three
 Values

Use the White of Your Paper

Value Creates Space

Value Creates Mood

Create Drama with Value—
 DEMONSTRATION

Create Drama With Color, 71

Color and Value Create Mood

Color Fundamentals

Another Way to See Color

Every Color Has Temperature

Blend Colors of the Same Value

Blend Colors for Luminous Darks

Neutral Tones Set the Stage for Color

Create Drama With Color—
 DEMONSTRATION

Exaggerate for Excitement, 95

Exaggerate Color

Exaggerate Darks and Lights

Exaggerate Size

Exaggerate the Story

Exaggerate for Excitement—DEMONSTRATION

Create Mood With Light, 113

How to Create Light

Light Moods

Luminosity

Create Mood With Light—DEMONSTRATION

Introduction

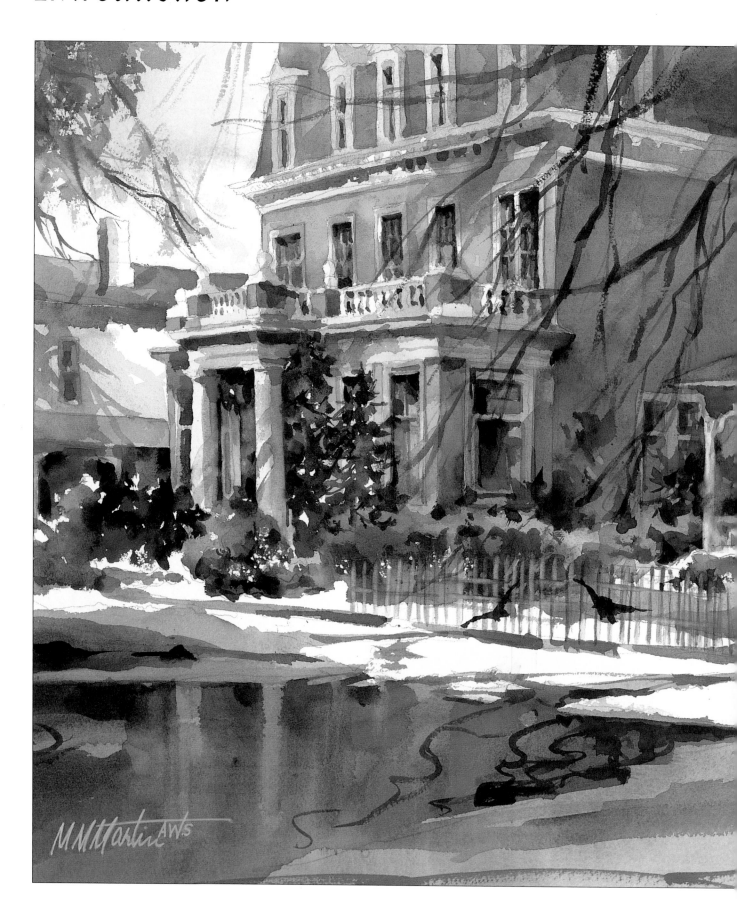

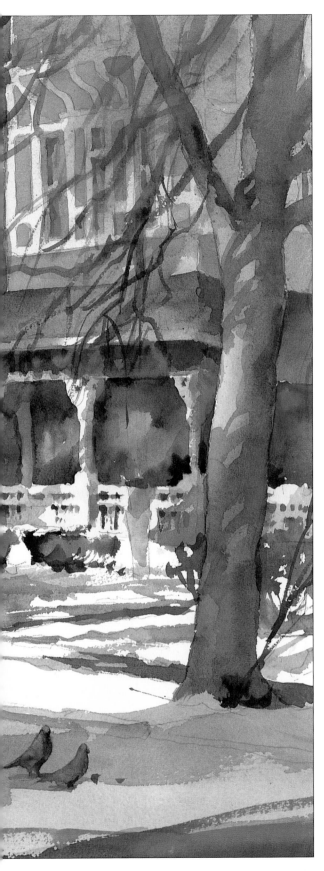

O ur society cultivates immediacy as an attribute. Watercolor's instant reaction of water to pigment and vice versa fits the concept perfectly. However, it takes patience to learn to control the water and pigment. So take your time getting acquainted with the medium and the problem-solving process. Grasp the fundamentals and then take off in your own direction. My way is one way; yours will be another.

This book includes painting concepts that are important and meaningful to me. Hopefully, you will relate to the thoughts. You can surprise yourself by the things you can create if you persist with the challenge and believe in what you are doing.

Painting for me is about involvement, both intellectually and emotionally. It comes from the heart and is the most interesting and meaningful endeavor I have discovered. I enjoy the search and reach for sincerity, honesty and excellence. A painting can affect people in very positive ways—often in deep, meaningful ways. An artist gives through art. The creative procedure isn't easy, but I wouldn't have it any other way.

My work is exclusively in the fine art world of transparent watercolor. I think of my painting as a profession, and go to work in my studio building located in a historic district of Buffalo, New York. It's there that I paint, present an annual studio show, meet with clients, teach a Spring Festival and Fall Festival workshop session and more. The work ethic is very much a part of my approach. I consider myself so fortunate to love what I do, and to be able to earn a living from it as well.

The pace of life today often allows no time for reflection, but the art experience demands time to reflect. Try to organize your time so that you have freedom to expand your visual world. Discover the moods and movements, the beauty and grandeur and the relationship of light and dark contrasts. Look for an expressive and imaginative viewpoint—a wonderment—and then respond with intensity. Cherish the fleeting moment when eyes, hand, mind and spirit come together. It is the process of genuine discovery and a time for celebration.

Distinctively Franklin Street
22" × 30"
55.9 × 76.2cm
Corporate collection

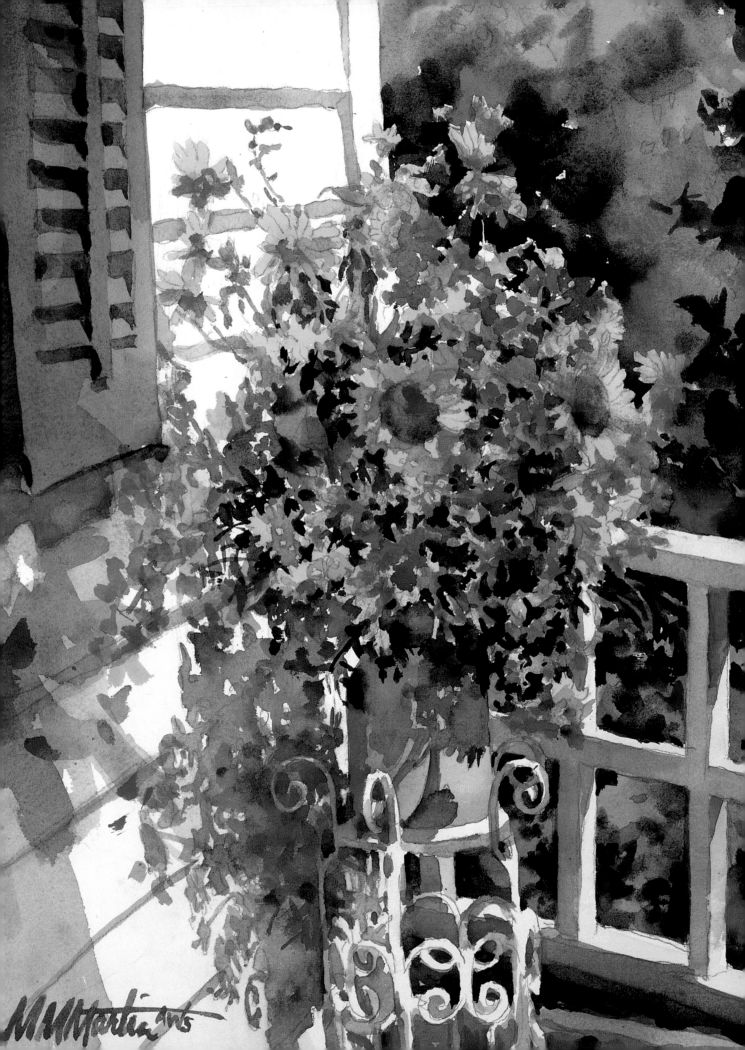

Materials

Many artists are concerned with what kind of equipment to use. Supplies are important, but more important is a sense of enthusiasm mixed with discipline. Go first for a love of image that radiates from your heart and eventually makes its way to your paper. Then think about the tools that you can manipulate to capture that feeling.

Materials

Supplies are personal. The more you paint, the more you'll discover materials that are right for you. I share my choices as a guide, certainly not as the only possibilities. My use of medium is pure, so my materials are basic to watercolor.

Paper

Think of paper as an integral part of the completed painting—physically, visually and texturally. There are certainly a variety of brands, surfaces, weights and white colors for consideration. Give them all a try. Only by experimentation can you make a decision with any conviction. The surface texture, the absorbency and the whiteness of paper are partners. It is the relationship of paper to paint that brings an unmatched beauty to a watercolor painting.

Try a smooth (hot-press), medium (cold-press) or rough surface. Whatever type you gravitate to, be sure to learn all its peculiarities—and then realize you'll always discover more. Just about any paper has potential as long as it is 100 percent rag content.

At present I use Arches cold-press paper, both 140-lb. (300gsm) and 300-lb. (640gsm). The hills and valleys of the cold-press tooth surface are right for my approach. A direct color application dries with vibrancy.

Tip

Treat both sides of the paper surface as a precious jewel. After purchase, always make sure you have clean hands before handling the paper. I am not opposed to using the reverse side to begin a fresh performance.

Brushes

A lot is expected of a brush. It must feel like it belongs in your hand. You should be able to rotate and roll the handle between your fingers. I hold my brush with a flexible grip—in fact, it is so loose that the brush has been known to fall onto my paper, usually in a most inappropriate place!

An assortment of pointed and flat brushes are part of my equipment. Because I use them so much, my quality pointed versions eventually lose their gorgeous points, but they give mileage and they work for me.

My favorite round pointed Winsor & Newton Series 7 sable watercolor brushes include a no. 10, no. 8 and no. 4. They hold just the right amount of pigment and water, and allow for a continuous stroke. Expensive they are, but the quality is worth it to me.

My flat versions are actually known as sign painting no. 4614 Grumbacher ox-hair brushes. A variety of sizes are useful—2-inch, 1¼-inch and ¾-inch (5cm, 3cm, 2cm). I enjoy ox-hair brushes because they can hold a large quantity of pigment and water.

A small bristle brush is helpful to lift or remove small amounts of color or to break an edge. An inexpensive version of this brush is a Fritch scrubber.

You don't need to use the most expensive brushes to paint a watercolor. What may be the perfect tool for another artist may not work for you at all. Whatever brushes you decide to use, be sure to clean them immediately after each painting session. Don't allow brushes to dry with color in them or to soak in water for long periods of time.

Tip

Brushes are my close friends. It takes a while to break one in—to develop its twists and turns—so I can't bear to retire a favorite one. I'll do almost anything to keep one going, even applying masking tape or friction tape to hold it together. The brush edges sometimes become worn, but I know its special characteristics and that's what matters. It's the result that I can create with only that brush that makes it so important.

Colors

A watercolor painting is dependent on the use of the best grade of color. You should eventually be master of the colors on your palette. This will take lots of painting time to develop, but keep in mind your colors should support each other to combine into a harmonious whole. You'll develop personal preferences. Try different colors, but remember that you don't need every available color to paint a watercolor. With too many colors on your palette it's easy to get confused. I suggest limiting your choices, especially in the beginning.

My present basic palette of colors consists of a warm and cool version of the three primary colors and a warm and cool earth color. I seek clarity, brilliance, strength, pliability and consistent handling characteristics. Most are Winsor & Newton, although I often use Grumbacher's Finest tube colors. I particularly like the rich darkness of Grumbacher's Burnt Umber and the pliability of Grumbacher's Cobalt Violet. All are premium grade colors.

I relate to the rich intensity, vibrancy, transparency and saturation of stain colors. Winsor Green is a staple. It can be a difficult color to control, but its power is an attraction to my nature to be direct and bold with paint application. Black is not included, because a more vibrant dark can be mixed. I use the white of the paper rather than white paint.

Warm Colors
- Winsor Red
- New Gamboge
- French Ultramarine
- Burnt Sienna

Cool Colors
- Permanent Alizarin Crimson
- Winsor Yellow
- Winsor Blue (Green Shade)
- Burnt Umber

Additional Colors
- Cobalt Violet
- Winsor Violet
- Permanent Rose
- Purple Madder
- Cerulean Blue
- Winsor Green (Blue Shade)
- Winsor Orange

Palette

The portability of a palette with a lid is so convenient. Excess pigment is sealed up and not wasted. The inside cover lid provides additional mixing space. Your art supply dealer has a number of selections. A John Pike palette is my choice. Use a hairdryer to harden pigment so it doesn't run out the edges when carried or tipped. The pigment can be softened with a few drops of water when ready to paint.

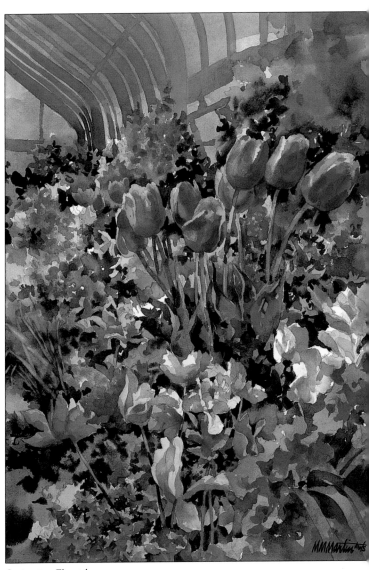

Springtime Flourish
30" × 22"
76.2cm × 55.9cm

Additional Gear

Include a collection of synthetic sponges—some to pick up in small areas and a large one to remove paper sizing.

Paper toweling and paper napkins are a must for wiping excess water from brushes, blotting areas on paper and cleaning palette surfaces.

I often rely on medium-weight treated acetate sheets that accept watercolor—a wonderful tool used as an overlay in the studio to determine contrast, color, shape or anything else on my paper. If I'm not sure of a solution, I grab one of these sheets to experiment; wipe clean and you have a clean sheet. It sure beats ruining that beautiful sheet of watercolor paper.

Work Space

I think it's important to have a designated place to work, whether it's in your home or elsewhere. It doesn't need to be the biggest or fanciest space, but it must have a work surface near your painting gear and away from unrelated distractions. It's hard to concentrate if you must set up and clean up each time, so you should direct your valuable time to the creative process.

Sketchbook Material

My sketchbook is an important tool for notes, preliminary sketches and value studies. Any sketchbook with coated paper indicated for felt-tip markers is good; 8½″×11″ (21.6cm×27.9cm) or 9″×12″ (22.9cm×30.5cm) is my preference. Sometimes I purchase a pad rather than a bound sketchbook, and have the individual sheets spiral-bound by a business that does that type of work.

I use broad-nib markers in black and grays for value studies. Cool Gray #3, #5, #7 and black, along with any fine-line, felt-tip black pen will work for the line drawing.

Use your camera to supplement drawings in your sketchbook, not to substitute. The camera is efficient and quick, but discourages true observation. It makes the eye lazy.

Some uses for your sketchbook are:
- Line drawings
- Black-and-white value drawings
- Black-and-white value statements
- Composition exploration
- Attitude search
- Reactions in writing
- Related items—photos, printed material, etc.
- Limited color statements

Sketchbook Exploration

I love the exploratory freedom of a sketchbook and have shelves of books filled with information from far and nearby trips, everyday sites, studio set-ups—things, places and thoughts that mean something to me. I can't overemphasize the importance of continued drawing practice and sketching. Drawing has never been easy for me, so a sketchbook is where I practice, practice, practice. I can only paint with confidence when I know my subject thoroughly.

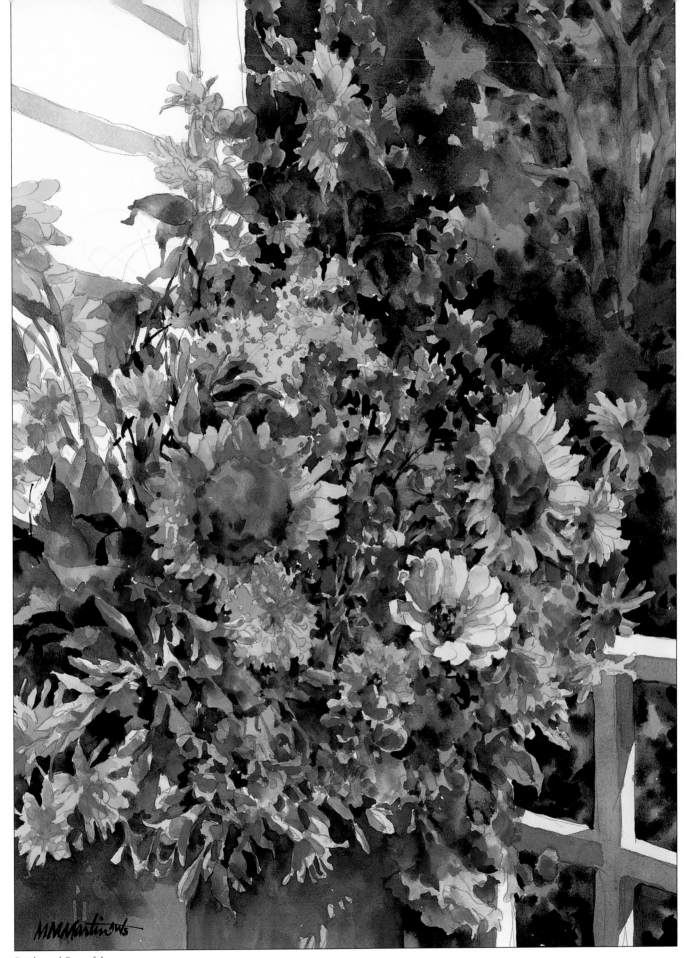

Bright and Beautiful
30″ × 22″, 76.2cm × 55.9cm

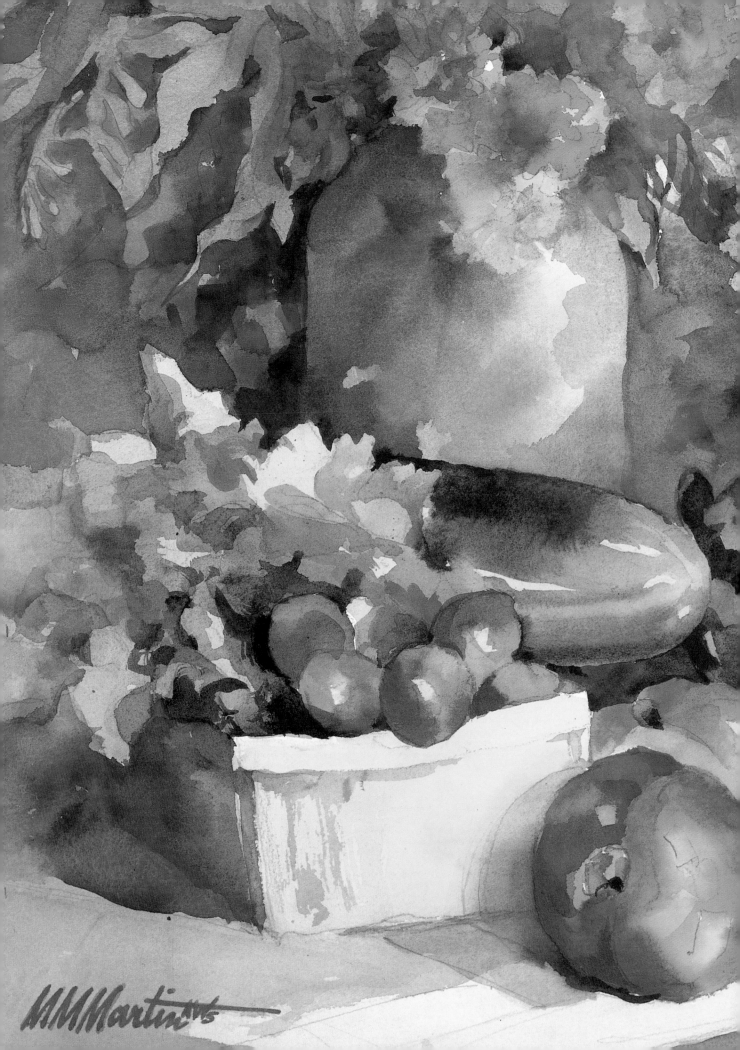

Control the Medium

You must learn to work in partnership with transparent watercolor. You can watch and read forever, but only by getting your feet wet can you create the real feel of pigment and water. Take the time to learn the craftsmanship.

Washes

Simply stated, color can be applied to paper with a brush by laying washes and by making separate strokes. Learning to lay a wash with confidence is basic language to watercolor painting. Master the art! Then you can be expressive with the wash and give it a painterly look that suggests atmosphere and light.

The basic wash is applied with a brush on dry paper and is even in value and color. Practice frequently laying a passage of fluid color rapidly over a good-sized-area. There are variations to the wash as described ahead but you really have to get the feel yourself.

E X E R C I S E Basic Flat Brush

Take one-eighth of a full sheet of watercolor paper, attach it to a board, and tilt it toward you at a slight angle. With a 1¼-inch (3cm) wide flat brush loaded with adequate pigment and water, pull a continuous horizontal stroke along the top edge, left corner to right corner. Work rapidly and without pressure. Surplus liquid will run toward the lower edge of the stroke, forming a long, narrow bead.

Use successive strokes from left to right, each a little lower than the preceding one but overlapping. Keep the moisture consistent. At the bottom, use less liquid and soak up the surplus with a damp brush or sponge.

Try many of these. Try different values and colors. Dark washes are usually more difficult than light. Discover what works for you.

E X E R C I S E Graded Wash—Light to Dark

Begin with a stroke of clean water across the top of your paper. Add a little pigment each time you fill the brush between strokes. The quantity of paint you add controls the rate of gradation.

EXERCISE Graded Wash–Dark to Light

Start at the top of your paper with a dark value stroke and add water each time you dip the brush, ending up with limited color. Practice! The skills you are gaining are invaluable.

EXERCISE Wet-Into-Wet

In this method, the paper is already surface wet (not soaking), and the color is brushed into the wet paper creating a natural diffused effect. Timing is important. If you wait too long with the paint layer, you will have hard edges when it dries. Too much water on your brush and not enough pigment will create a big problem. Think out your attack, jump in, be assertive, and say a prayer! You learn to feel by doing.

Strokes

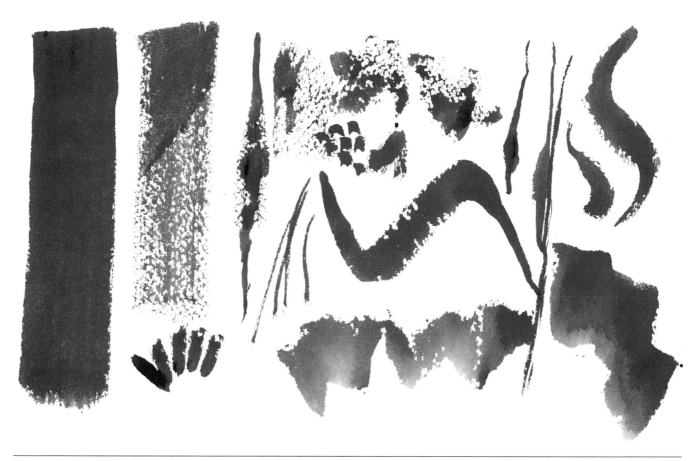

EXERCISE

Make some solid strokes with the full brush width. You'll see
how differently varying amounts of pigment and water in the
brush react. Move the brush slowly; move it rapidly, hitting the
hills and valleys with white paper showing through. Use the
point tip, center section and base of the brush. Roll the brush
on its side. Use both light and heavy pressure. Use the natural
flexibility of the brush. Practice brush handling, and build an
agility for twists and turns. Aim for brush control as well as
variety. Everyone feels awkward at first. Be inventive!

Edges

Edges represent a key repertoire in a watercolor painting. It's light that determines edges. Some are crisp, some are diffused, some are rough and some are lost and found.

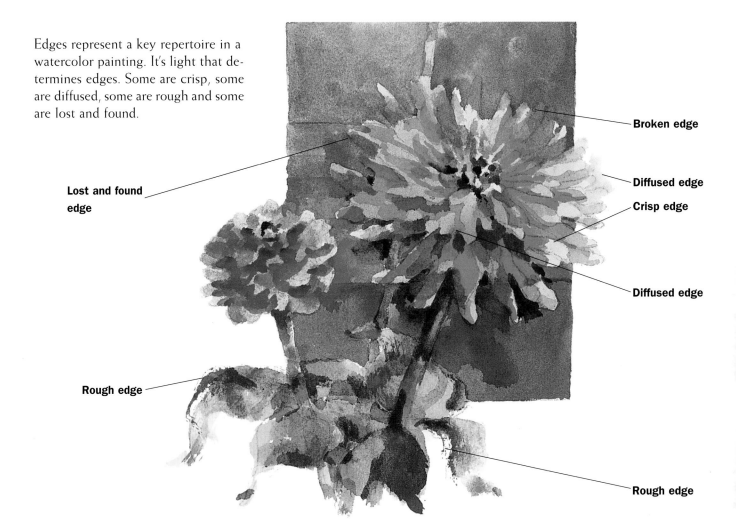

Lost and found edge

Rough edge

Broken edge

Diffused edge

Crisp edge

Diffused edge

Rough edge

Crisp Edges

These edges establish a focus, and portray strength and emphasis. They describe structure. Diffused edges dramatize crisp edges and give variety.

Diffused Edges

These edges can express a mood, give illusion to a curved, receding surface, as well as suggest a spacial illusion. Crisp edges dramatize diffused edges and give variety. Softened edges can be added for interest and to provide passages from one area to another. Soften by lessening the value or color contrast of adjacent areas.

Rough Edges

These edges can create variety and character in a statement. They are usually described on dry paper. Edges of trees, foliage, rocks and shadows are possible opportunities. You will invent more.

Lost and Found Edges

The nature of the watercolor medium suggests fluidity from one area to another. Lost and found edges give you an opportunity to move in and out of areas, forming a connection—a movement that motivates the eye and eliminates a stiff appearance. Everything doesn't need to be equally described. Allow the viewer to participate and inject a spirit of imagination.

Lost edges can create unity by eliminating specific shapes. Squinting helps you to visualize lost edges. Eliminating edges in areas of similar value unifies the composition. All sorts of things blend together in nature; lost edges create mystery, interest and flow. Sharply defined edges are needed for value contrast, different color and definition.

Celebrate Bigness

It took me quite some time to realize that painting is about bigness as opposed to smallness . . . simplicity as opposed to detail . . . the whole as opposed to the parts.

Think Big! Think Abstractly!

Big non-static areas arranged in an interesting manner will be the construction of your painting. Small areas are accessory and embellishment and will particularize and individualize. Personal taste will dictate the number of small areas you wish to indicate. It seems to be human nature to go for detail first (myself included!). But just as in life, look for the major elements first, and the small elements usually fall into place. Remember, fanfare without solid big structure will fall apart and be artificial.

Think Big

Use big brushes; they stimulate big thinking. Small brushes encourage small thinking at this stage. The key is to be more interested in the art of building a painting than in painting a picture of something. Subject matter is simply a point of departure.

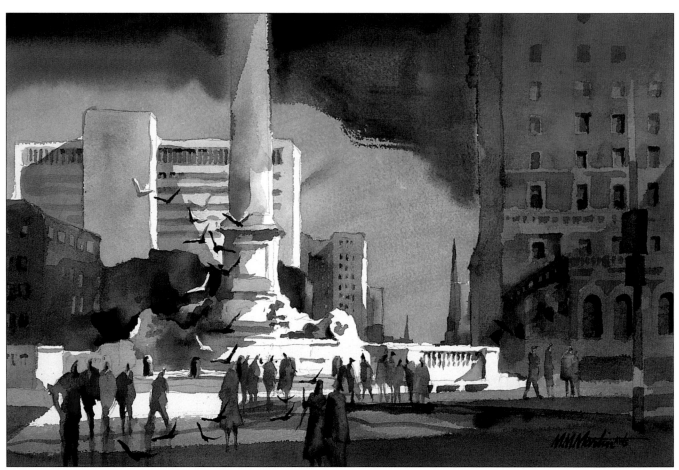

Place the positive form (monument) off-center in order to present an unequal amount of air on each side. Dominance and repetition of vertical movement help to create unity. Big areas surround the center of interest, creating containment.

Urban Sparkle
15" X 22"
38.1cm X 55.9cm

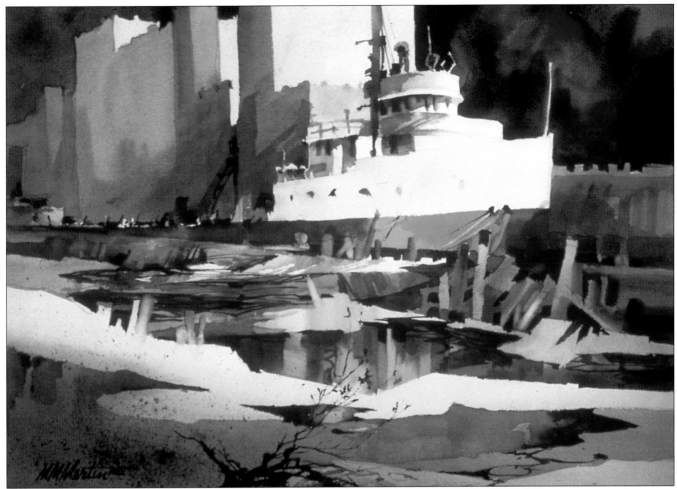

This painting received national recognition, but that's not my real reason for liking it! The geometric pieces that fit and interlock into a unified wholeness are appealing to me. The structure is fundamentally a combination of repetition, order and variety. In reality, the abstract qualities of the middle and background areas were there for me to recognize and grab. The foreground area needed to be designed to motivate the eye to the focus.

Queen of the Lakes
22" × 30"
55.9cm × 76.2cm

Think Big

Four guides to identify bigness:

- Look for big background area.
- Look for big middle area.
- Look for big foreground area.
- Look for major focus area.

Exericse

Play a game with yourself by looking for big, abstract, geometric arrangements in paintings—any medium will do. It's sometimes easier to begin with work other than your own; you're not as involved with the subject and don't have an emotional attachment. Perhaps you have a favorite Old Master painting. Place tracing paper over a reproduction and make a line drawing of the major areas. This diagram will help you develop confidence to translate and analyze this concept in your own work. Look for the large areas and how they interlock into smaller areas. Notice how your eye is guided to the focus area.

Positive vs. Negative

A painting is primarily a flowing partnership of positive and negative space. Thinking in terms of positive and negative form will help you organize and determine the placement of the large mass on your paper. Look for the relationship of surrounding solids with surrounding air. The subject is positive space; the air around it is negative space.

Walter Murch, a highly regarded American painter who I was privileged to have as a drawing instructor at Boston University, said, "I must not paint the thing itself, but I will paint the air between myself and the thing and beyond."

Positive

No question about what the center of interest is, but I think you will agree that this placement is static and uninteresting. The positive area floats in the middle of a large negative area, which has little relationship to the whole paper.

Negative

The negative area does not showcase the subject. It dominates and presents equal air on each side of the subject. The negative area is not what attracted me to this theme.

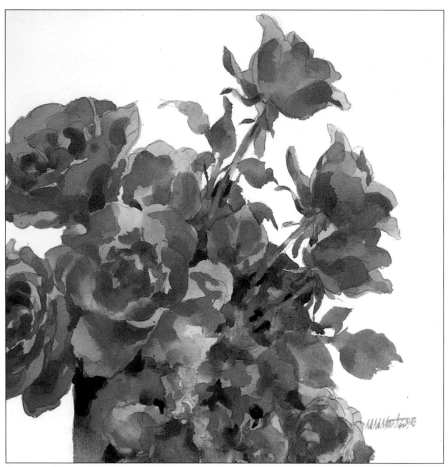

Signature Design
12¼" × 14", 31.1cm × 35.6cm

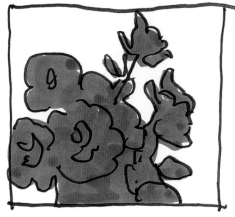

Solution

By extending a few positive shapes and making the focus larger, a more interesting contour is achieved. The positive now dominates over negative; the relationship is better organized. The anchored container adds solidity and directs the eye to the theme.

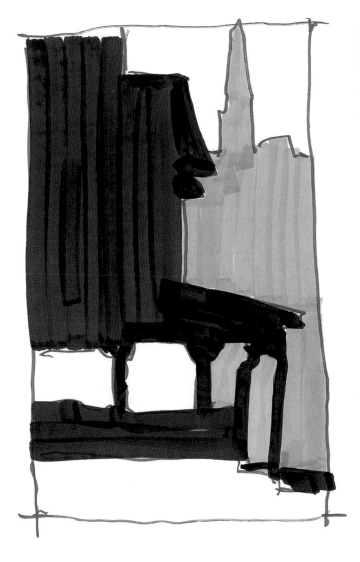

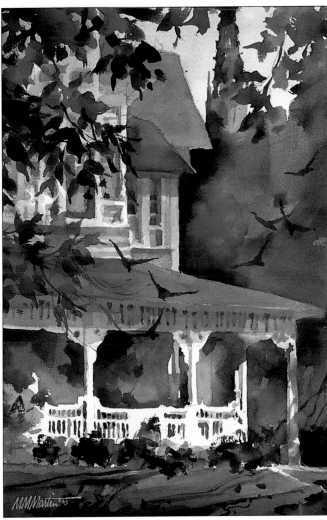

The church steeple is behind a neighboring house. Eliminate the detail and treat the entire area as one mass—"bigness!" Imagine you are putting a jigsaw puzzle together. First discover the largest piece, then the next largest and finally the smallest pieces. They will all interlock to make up the whole. The house gingerbread character is embellishment.

Interlock Areas

Areas with uneven dimensions are likely to be more interesting than symmetrical ones. Look for unequal areas that can be complemented by interlocking. Aim for big, simplified shapes that present a silhouette with character.

Leading Lady
22″ × 15″
55.9cm × 38.1cm

Think Big

Blank white paper is beautiful; it is unified. Marks, lines and mass will interrupt this unification unless you make a conscious effort to place your focus in a meaningful location. Decide the paper proportion—a rectangle (horizontal, vertical)? A square? The actual dimension is your choice.

Use the Edges of Your Paper

You are the orchestrator of space. By connecting your composition to the picture border, you cut down on extra background space and create organization and movement for entering and exiting. The goal is to let your eye wander throughout, but always return to the most important point.

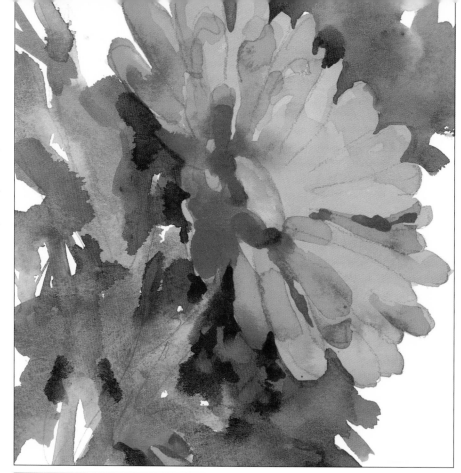

EXERCISE Extend Your Areas

Take one flower and stretch part of it to an edge. Interrupt the top edge, then balance one or two other edges with foliage or background. Do several of these on small sheets of paper. Be aware of the total positive element as it relates to the total negative element.

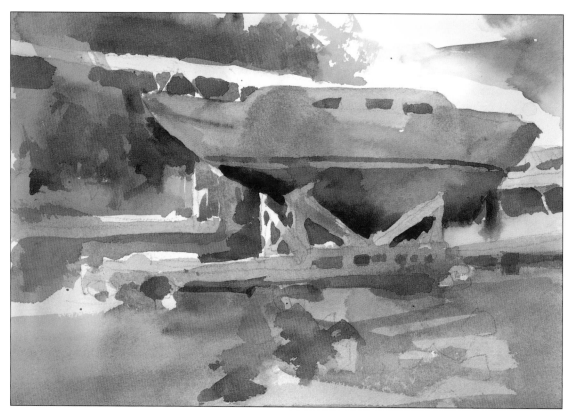

EXERCISE

Choose a subject that you know and enjoy. Do several studies where you take advantage of paper edges by extending and connecting the background, midground and foreground. You will probably need to be inventive.

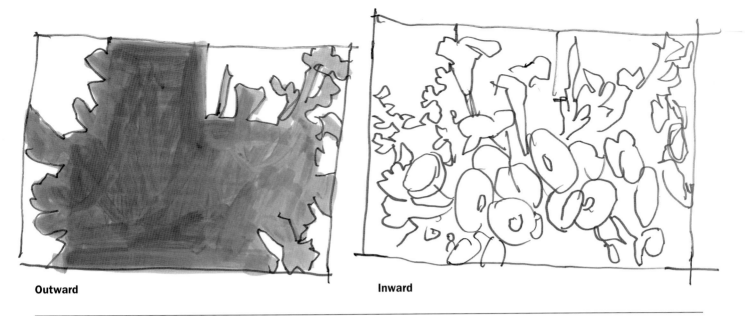

Outward

Inward

EXERCISE Outward to Inward

You might sometimes consider working "outward to inward." Have a subject nearby, draw an abstract shape on your paper inspired by the subject. Make sure it fills at least three-quarters of the space and connects to the paper edges. Give some thought to designing an irregular silhouette. This is your positive "outward" area. Now, work "inward" by indicating individual shapes and other details. This approach allows you to begin with a "bigness" and forces you to use paper edges.

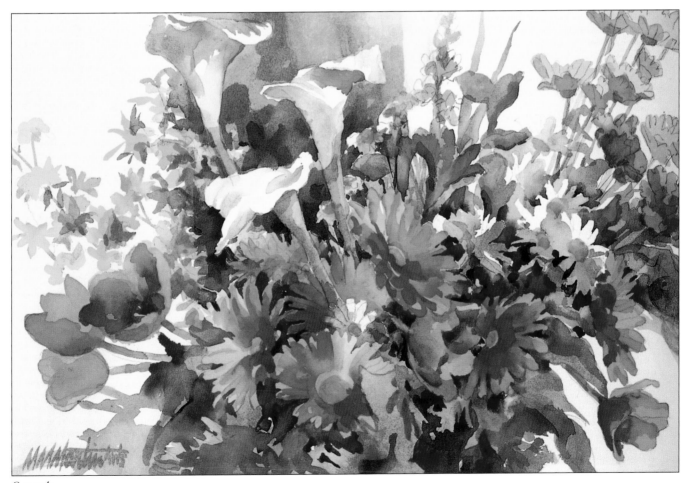

Crescendo
15" × 22", 38.1cm × 55.9cm

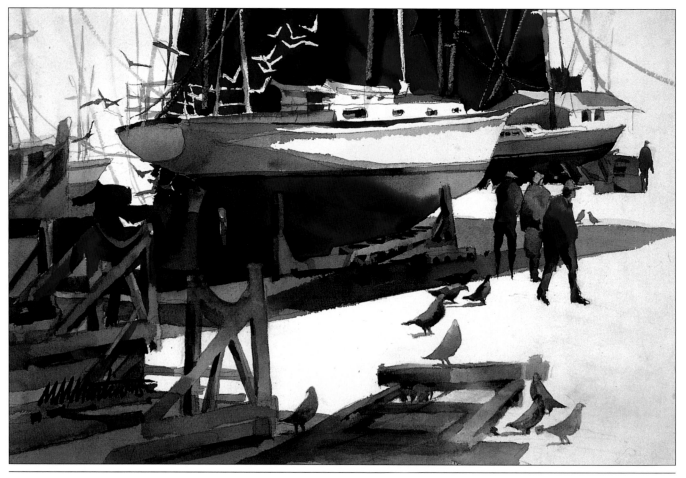

EXERCISE

The boat is the primary attraction, so draw that shape first. Working "outward," draw an arbitrary abstract area that connects the paper edges to the subject. Be sure the positive space is larger than the negative space. It's fun to select and design smaller areas to fit into the whole; try this with subjects that you relate to.

Marina Design
15″ × 22″
38.1cm × 55.9cm

Think Big

The bigness and extension of your painting has to develop out of the demands of the painting and its subject matter. Use your creative instincts and be a little daring. Let the bigness flow and grow from your theme.

Positive

Negative

EXERCISE Positive vs. Negative
Try working "inward" to "outward." First draw the positive area—expanding and connecting to the four edges. Overlapping one or two of the structures creates "togetherness" rather than "separateness." Both the positive and negative areas are intriguing masses.

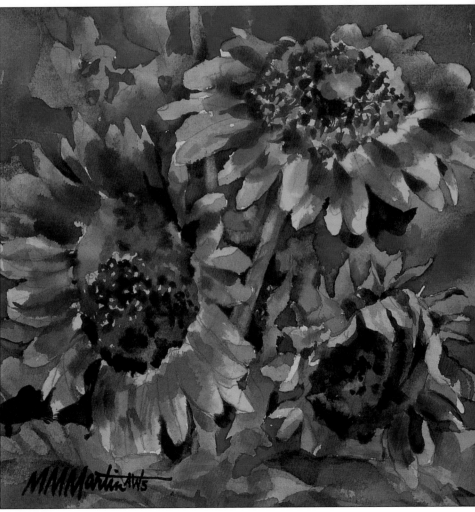

Sunset
11" × 11"
27.9cm × 27.9cm

Design Big Areas to Highlight Your Center of Interest

How do you map out a route to your final destination? It will most likely be the major routes which will connect to your designated highlight.

Look at this process as a game. You are in control as a navigator. There are not many situations in this world where you have complete control, so let's go for it! Several routes are usually available. Do you want to reach your focus as quickly as possible, or do you want to meander a bit and make a few stops before you hit your destination? Movement, overlapping, underlapping, containment and circulation are possible solutions.

Follow along as I share some directions and reasons that I selected to arrive at a center of interest.

Think Big

Deciding on a route to the center of interest is logical as well as intuitive. The route for me usually evolves through natural selection as well as gut feeling. Don't ever underestimate your individual perceptions. Contrary to our technological society, art is about emotion, individuality and making choices that feel right. Be yourself.

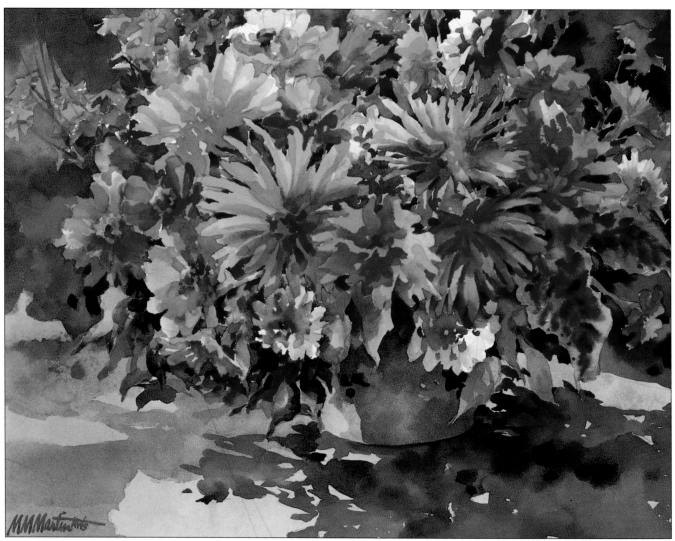

An angled cast shadow suggests solidity and connection as well as variety in shape. The eye needs help and direction to arrive at the emphasis that contains multiple shapes, contrasts and colors. It doesn't take long to reach the emphasis.

Royal Dazzle
22" × 27"
55.9cm × 68.6cm

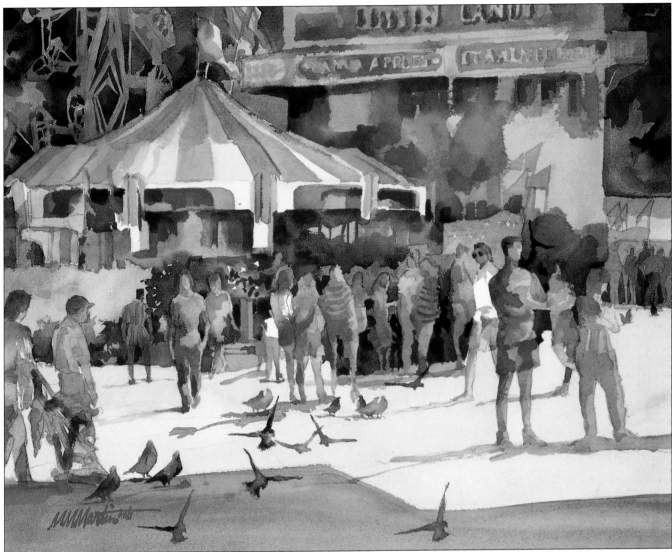

This is a busy subject and an ongoing series with me. A substantial number of sketches were accumulated and correlated into this arrangement. The big foreground and background areas contain the midground, which stages the center of interest. Figures overlap foreground into midground, and help unify and direct the eye toward the activity. The oblique foreground cast shadow suggests movement and another dimension. The "bigness" of the foreground area presents a direct quick route to the destination.

Carnival Theatrics II
18½" × 24"
47cm × 61cm

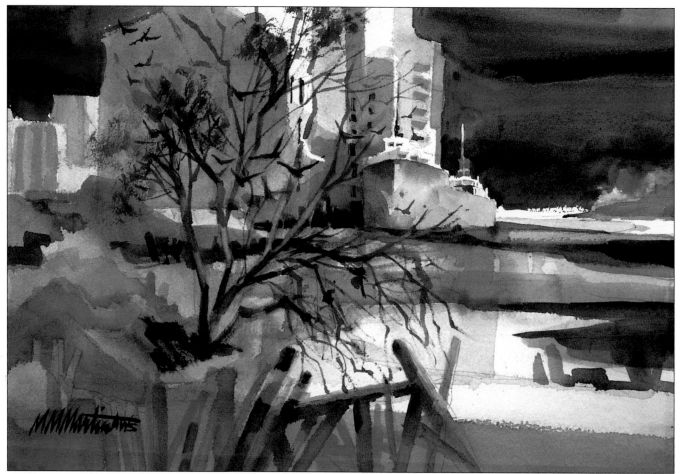

Let's grab a 2-inch (5cm) flat brush and lay in all the areas except the subject. The big massive foreground can be fractured as much as you choose with horizontal and diagonal directions; all aimed to the focus. The simplified area behind the focus helps to keep the eye anchored.

Port Patterns
15″ × 22″
38.1cm × 55.9cm

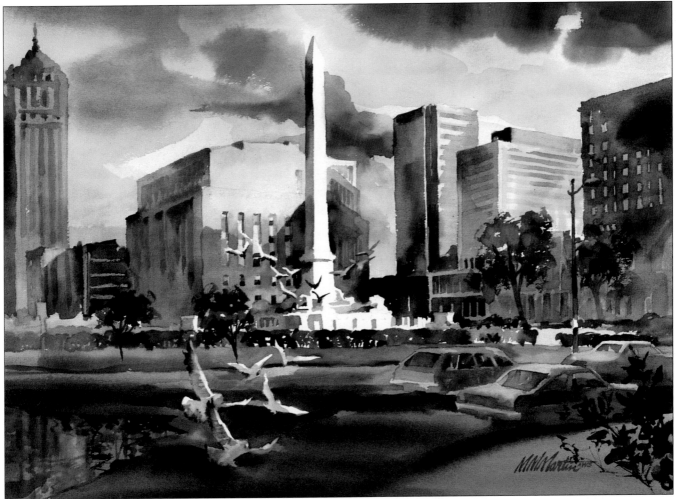

The big foreground area is containment for the subject. By overlapping this area with the curving direction of the bird's flight, the eye is motivated to the center of interest. The angled dark area in the sky suggests shape contrast to the perpendicular nature of the theme.

Urban Drama
22″ × 30″
55.9cm × 76.2cm

Celebrate Bigness

Let's spend a morning in the park! The air is fresh. The sun is glorious and bright. The shadows are crisp. The symphony of chirping birds is mellow and consistent. The grass is laden with dew; freshly-mowed is the fragrance. Space is expansive and big. It's the bigness in everything, as opposed to the smallness, that is so dominant and attractive. Allow all your senses to be open for inspiration!

STEP ONE

Exploration

Photography is a wonderful tool for a starting point but not for a finishing point. Keep your camera ready to capture whatever appeals to you. This scene radiates a broad foreground and distinct midground and background areas. With composition, value and color adjustments, it could be a point of departure for a painting. Let's try!

Look for large abstract shapes. A line drawing of the foreground, midground and background areas will help to simplify and determine the division of space. Do the separate shapes have character? What about a big background area with a small foreground area? What about a small background area with a broad foreground area? What about using the paper edges to create additional divisions? How do the puzzle pieces fit together?

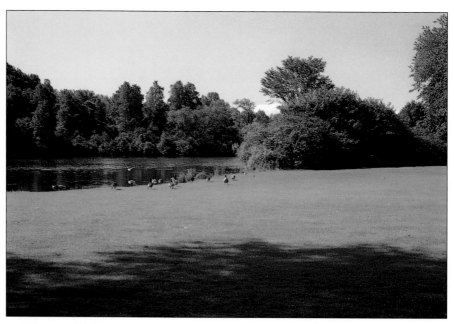

Photograph Reference
This is one of the reference photos taken while in the park. It is sometimes fun to take a common scene and try to present it with clarity and sparkle.

Simplification
Use the reality of a scene to abstract the bigness. Force yourself to simplify and improve the important shapes.

STEP TWO

A value sketch gives an opportunity to make adjustments from the original photograph and to breathe life and vigor into your subject.

At this time, I decide to add more interest to the background foliage contour by interrupting the paper edge. I decide to narrow the sky shape. Thoughts dashing through my mind include:

1. A realistic painting is a good abstract painting.

2. The relationship of dark to light will create depth and an illusion of space.

Value Sketch

It is not a good idea to work exclusively from a photograph. Incidentally, be sure the photograph is your effort. It is often difficult to see into a photograph's dark areas. It is also illegal to use someone else's photo without permission. Make a value sketch from your photograph to fully understand the structure and value relationships of your subject.

STEP THREE

Establish a careful drawing on a half sheet of Arches cold-press 300-lb. (640gsm) paper. Begin by establishing the horizon line approximately two-thirds high on the paper. Remove the paper sizing. The paper is dry. Use a no. 10 round brush to lay in clean water for the whites of the clouds in the sky. Gently blot with a paper napkin. Immediately, lay in light Winsor Blue (Green Shade) with a bit of Burnt Sienna, letting the wash merge with the clean water wetness. While still damp, charge in more pigment of Winsor Blue (Green Shade) at the top for drama and containment. Let the natural action of the medium take charge.

While Winsor Blue (Green Shade) is in your palette mixing area, lay in the water shape and mix some Winsor Green (Blue Shade) in the mixture. This is light value. Paint around the white bird shapes. This is why a well thought-out drawing is important!

STEP FOUR

Thinking "Big," take a 1¼-inch (3cm) flat brush saturated with Winsor Green (Blue Shade) and New Gamboge and attack the broad foreground mass like a house painter! Be decisive—no scrubbing! This is light value. The mid-ground foliage has light at the top, so connect into this area with the same color and value. For unity and bigness sake, always seek a way to connect or weave one ground into another.

While foreground mass is damp, paint wet-into-wet with Winsor Green (Blue Shade) and Burnt Sienna, Winsor Green (Blue Shade) with French Ultramarine, and Winsor Green (Blue Shade) with Cobalt Violet for dark cast shadows. Leave alone!

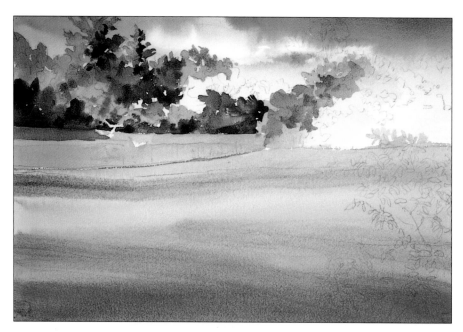

STEP FIVE

The background foliage is seen as a large mass—individual trees merge into the whole. Paper is dry. Let's strike in a light green value of Winsor Green (Blue Shade) and New Gamboge and merge into Winsor Blue (Green Shade) and Winsor Green (Blue Shade) and French Ultramarine. While damp, add a dab of Winsor Orange and Winsor Red to create focus. The eye will gravitate to the white bird shapes, so let's suggest color interest to break up the green monopoly.

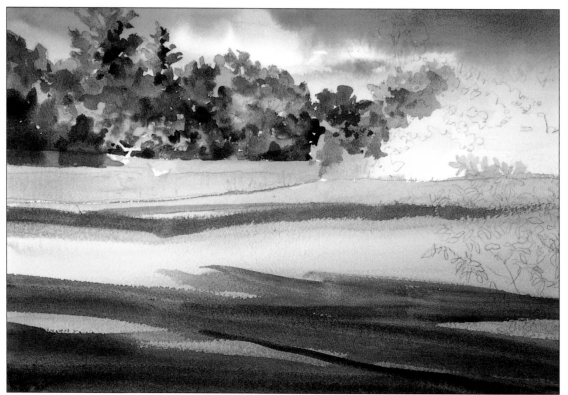

STEP SIX

Complete the background foliage mass with middle and dark greens. Continue to think in a big abstract pattern rather than individual things. The contour will establish the character more than the interior elements. The darkest dark is Winsor Green (Blue Shade) mixed with Permanent Alizarin Crimson.

The foreground cast shadows need to be darker. Mix Winsor Violet with Winsor Green (Blue Shade) and Burnt Umber for added depth and balance.

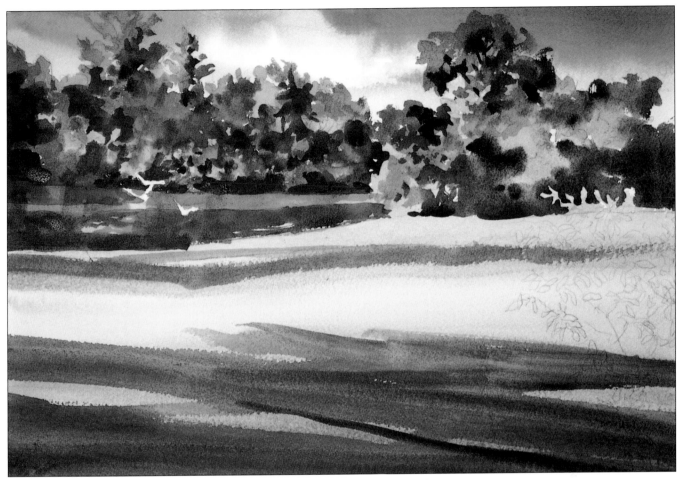

STEP SEVEN

The water needs to be defined. A dark value of Winsor Blue (Green Shade) and Burnt Umber establishes space. Be careful again to paint around the white bird shapes.

The bigness of the middle foliage area is laid in with similar color mixtures as in the other areas.

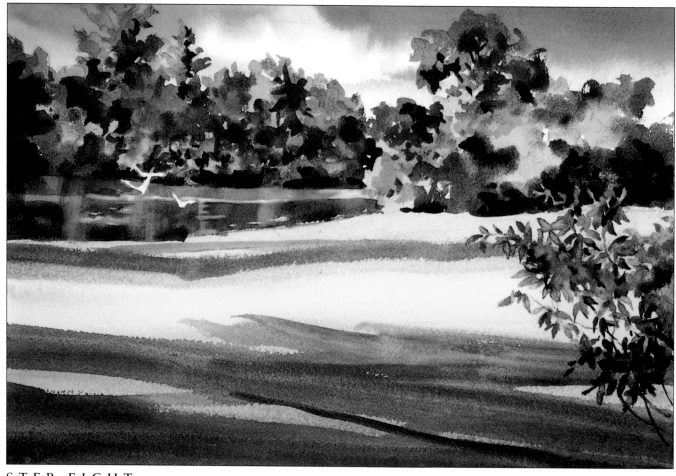

STEP EIGHT

The foliage detail at the right edge provides a connection between foreground and midground. It is the contour of the leaf detail that gives character. Half close your eyes; you will see mass.

The water needs some "wiping out" to suggest reflections. An oil bristle brush is helpful to indicate additional horizonal reflections.

Think Big

Bigness is really about abstract unity and simplification. In this painting, the merging of foreground into midground into background creates a simplified unity. What to put in and what to leave out is a major consideration. Every painting is a new adventure!

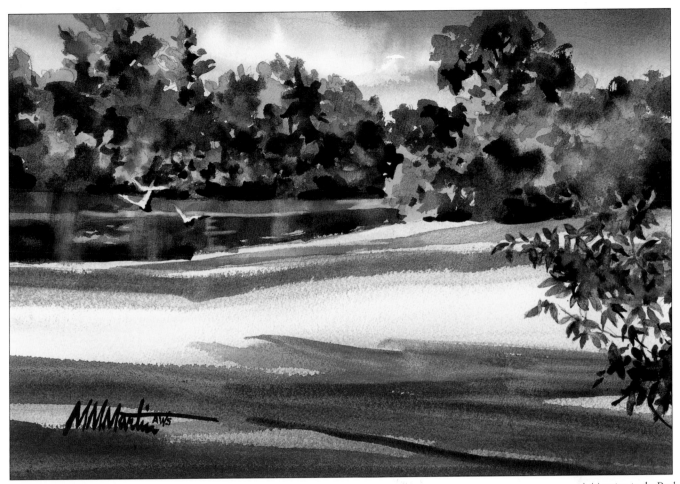

STEP NINE

Consider the placement of your signature. I feel that a small dark detail in the left corner would help balance the detail on the other side. Let's use the signature as the touch.

A Morning in the Park
15" × 22"
38.1cm × 55.9cm

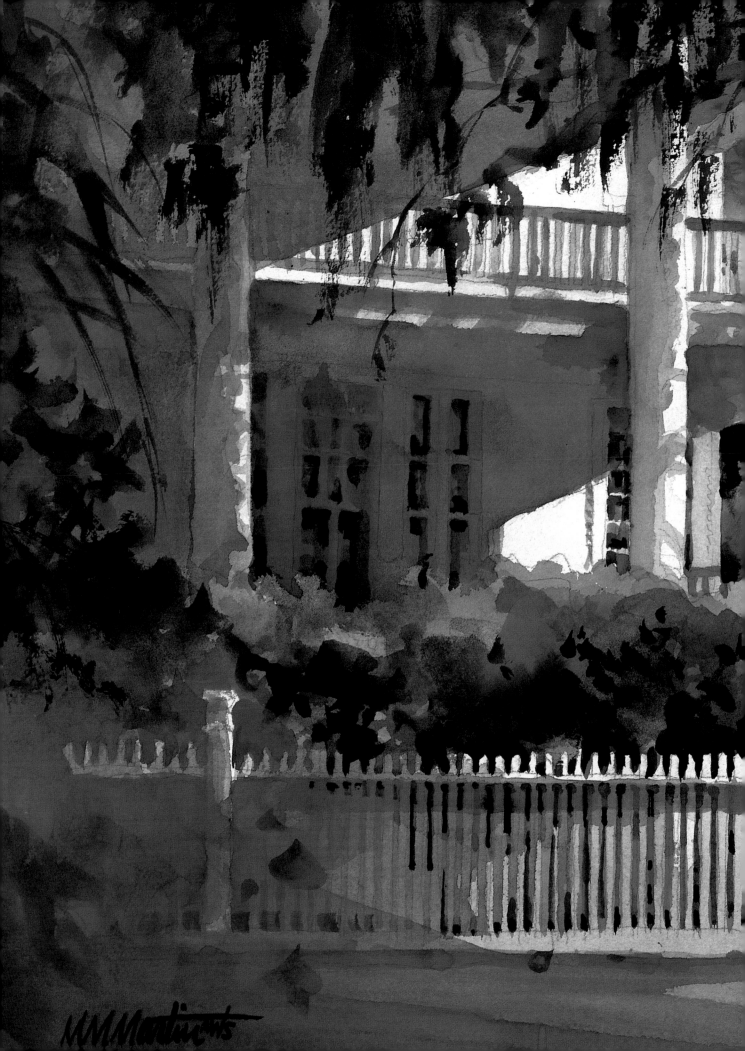

Create Drama With Value

I was bewildered when I first encountered "values." With more painting experience, I discovered value is more important than color. Most of the Old Masters relied on value patterns and contrasts to describe the effects of light. If your values are reasonable, any color will likely be appropriate. So even though I gravitate to color, value comes first.

What is Value?

Simply expressed, value is the lightness or darkness of color. It transforms a two-dimensional piece of paper into the illusion of three dimensions. Value is light falling on things; it creates movement, and its flow will unify areas. The relationship of strong dark and light contrast creates drama that attracts the viewer to the focus area.

As children, we're taught to recognize and identify color. Rarely are we asked to relate dark to light. I think our aesthetic life would be enriched if we were presented the opportunity to visualize the value phenomenon at a young age. We need to plant a sense of appreciation for nature's artistry in young people. How thrilling to witness children's expressions of wonder and magic as they trace a cast shadow on a tree trunk with their hands! Give it a try!

If this is a new concept for you, you're in for a visual treat and will be amazed at how much more beauty you actually see and appreciate. Be patient!

Think Value

- The greater the value contrast, the greater the dramatic impact.
- The greater the value contrast, the greater the depth of spacial illusion.

EXERCISE How to See and Judge Values

You must make comparisons. Look for the lightest light and darkest dark, and compare everything else to them. Everything in between is your middle value. Outdoors, it helps to have a sunny day; indoors, a spotlight on your subject is beneficial. Squint, and the darks and lights will pop.

I was attracted to this doorway because of the dramatic light and dark contrast. French Ultramarine Blue and Burnt Sienna are the two colors used here. Make a pencil drawing followed with the direct laying down of tones—lightest first, progressing to darkest. Zero in on a subject that appeals to you—something that presents strong light and dark contrast. Use one color if that's simpler.

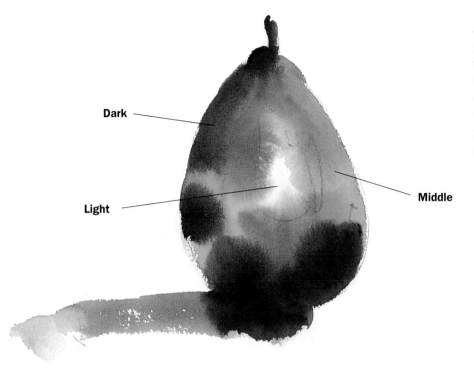

Dark

Light

Middle

A good way to get started is to select a piece or two of fruit and place them on a white surface. Direct a spotlight on the object so that a cast shadow can be easily detected. Squint, and the lights and darks will be pronounced. Try a number of these studies. Vary the lighting. This concept is learned by looking and doing!

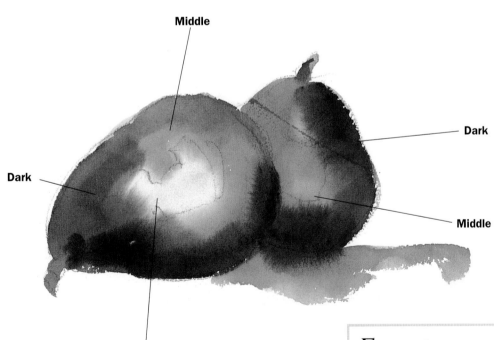

Middle

Dark

Dark

Middle

Light

Exercise

Practice seeing values by looking at subjects while doing errands. Imagine what a black-and-white photograph of your theme would look like. Ask yourself, "Where is the darkest mass?" "Where is the lightest mass?" "Where is the in between—the middle mass?"

Value Chart

Seeing values is a mental as well as a visual process. You will at times need to invent and exaggerate contrast for dramatic impact. This is part of the creative process.

Let's make a black-and-white value chart of ten values for reference and understanding. Keep it in your sketchbook as a guide for comparing value intensities on location or in your studio. This is a very useful tool.

Think Value

Don't get lost in all the subtleties. Keep it elementary. Three values (light, middle and dark) in addition to white paper and black do just fine. Learn to see and think value in this manner. Make a simplified black-and-white value chart using the information established in the major chart.

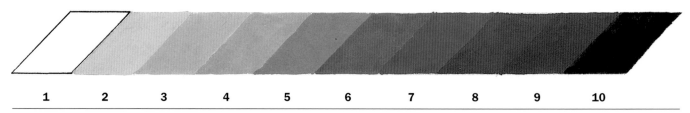

| 1 | 2 | 3 | 4 | 5 | 6 | 7 | 8 | 9 | 10 |

E X E R C I S E Black-and-White Major Value Chart
Begin with white paper on the left and black on the right. Strike a gray between these two extremes, and put in the middle. Mix gray with white and black, and continue until the other spaces are filled. Markers, charcoal or pencil can be used if preferred.

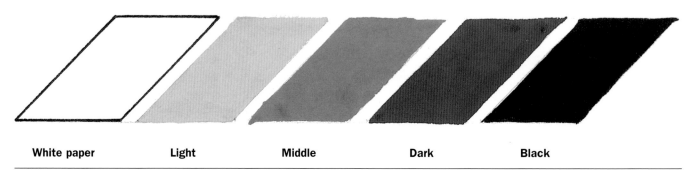

| White paper | Light | Middle | Dark | Black |

E X E R C I S E Black-and-White Simplified Value Chart
Simplify the process of the major chart. Squint while holding this guide up to your subject. You will have a believable reading of the relationship of values.

Build a Value Sketch

Follow along with my step-by-step approach to value sketches. Don't be fanatical about duplicating the exactness of value nuances. Aim for a simplified, believable expression of three tones—light, middle and dark (as well as white paper and black). The original size of these sketches is 8″ × 5¼″ (20.3cm × 13.3cm), so adjust when enlarging to a full sheet. As in painting, it is not always necessary to systematically progress from light to dark; sometimes a dark will come before a mid-tone. It is the end result that counts!

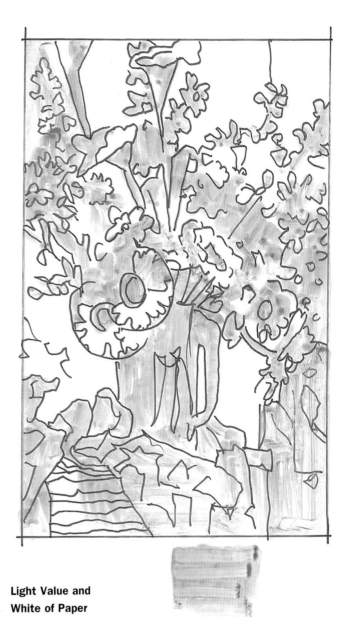

**Light Value and
White of Paper**

No. 3 Cool Gray Marker

S T E P T W O

Indicate Light Values
The whites in light need to be identified and saved. As in the language of watercolor, keep in mind that dark tones can be stroked over light tones, so don't be afraid to lay in a light value where you think a midtone appears. Your motive is to cover the large areas as quickly as possible; think wholeness. Use a no. 3 Cool Gray chisel-point marker.

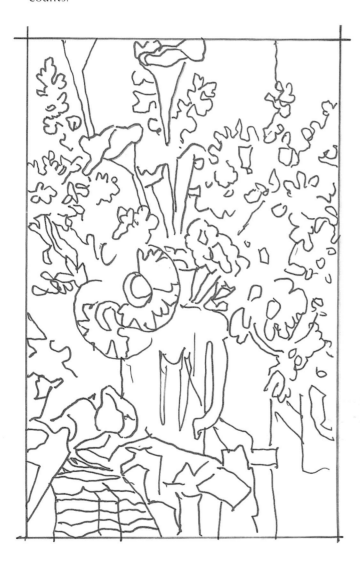

Line Drawing
S T E P O N E

Create a Line Drawing
Take time to compose your subject. Think about interrupting paper edges. Make a contour drawing with a felt-tip pen.

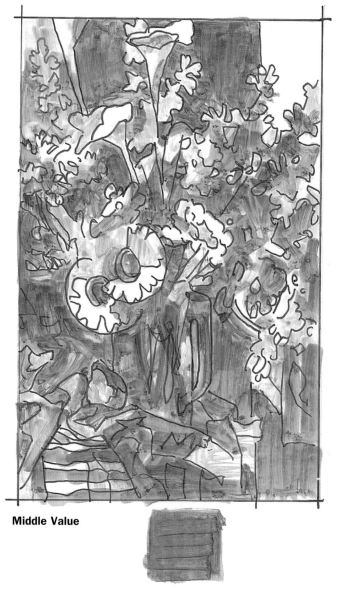

Middle Value

**No. 5 Cool Gray
Marker**

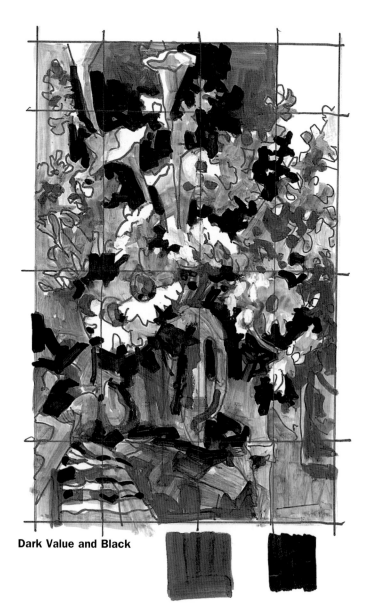

Dark Value and Black

**No. 7 Cool
Gray Marker**

**Black Chisel-
point Marker**

STEP THREE

Locate Middle Values

A no. 5 Cool Gray chisel-point marker states this value
well. The structure of the midtone area links the light and
dark masses. It covers the bulk of your paper if you use
the full range of values. You may be hesitant of your direc-
tion at this point, but hang in a bit longer, for just as in
painting, you haven't gone far enough.

STEP FOUR

Dark Value Punch

A no. 7 Cool Gray and a black chisel-point marker will
provide drama and emphasis. It is not necessary to be in-
volved with the character of individual petals. Check to
see that your darkest dark against your lightest light is
where you intend to have your focus. Attempt to weave
the darks throughout.

Think Value

A value plan must be established. It is part of the craftsman-

ship of painting. Believe me, the discipline and time spent

in this process will enhance freedom and directness in your

painting. Knowledge breeds confidence!

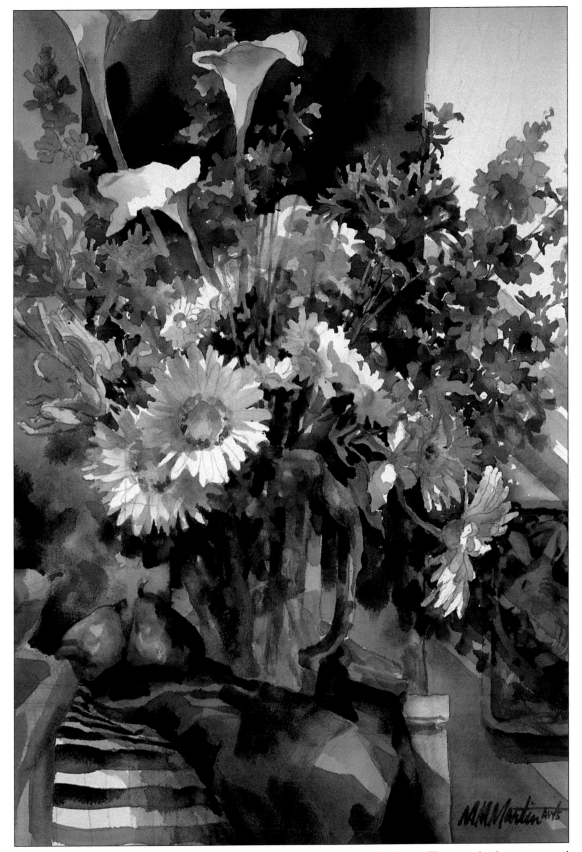

At last, ready to paint! The sketch served as a guide for *Too Handsome To Forget*. The actual subject is staged before me. I can paint entirely from my sketch; any colors selected will work, as long as the values are in the ballpark.

This still-life arrangement with real flowers was a setup at one of my annual studio Spring Festival floral workshops. The darks surrounding the lights of the lush bouquet create value drama. A spotlight was directed to the subject; it showcased the jewel-like shadows and sparkling lights. It was gorgeous!

Simplify the Value Dilemma—Use One Color

It can help organize your thoughts to paint a value painting with just one color. While painting on location in New Mexico some years ago, Yellow Ochre was the color that shouted at me, so I decided to attempt a value painting in that color.

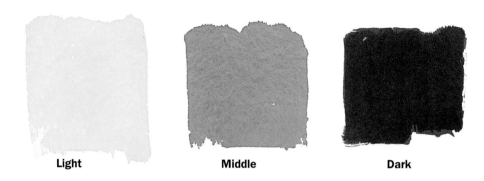

Light **Middle** **Dark**

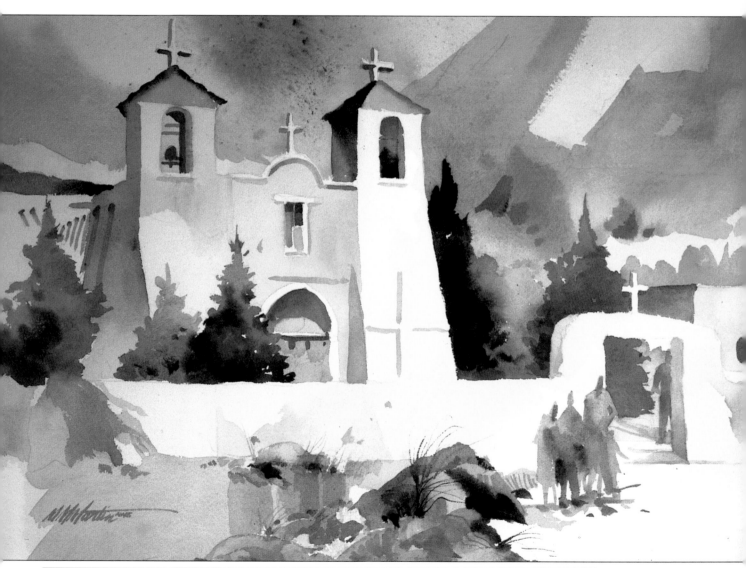

The Feel of New Mexico
15" × 22"
38.1cm × 55.9cm

EXERCISE

Select a color that emotionally relates to your subject. On a small piece of watercolor paper, lay down three swatches, indicating light, middle and dark intensities of that color. Pay particular attention to the relationship of middle value to white paper. The contrast is usually greater than what you imagine. Use these swatches as a guide while progessing with your painting.

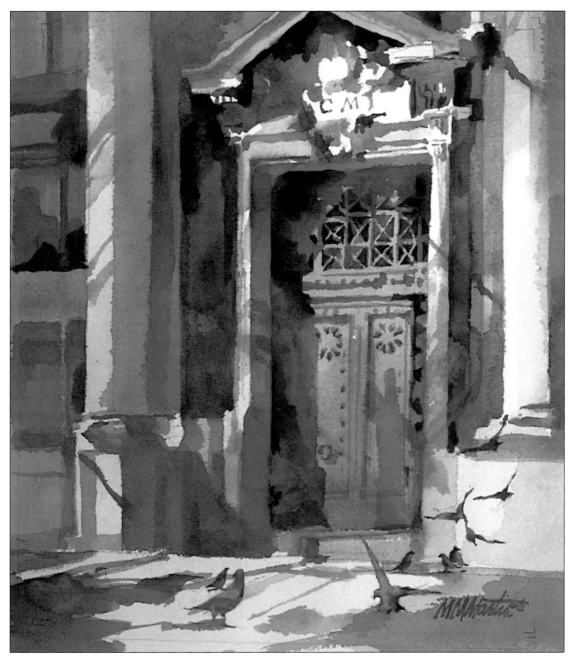

Use a Limited Palette

Many respected and successful artists choose to work with limited color. Even though I love color, this approach has taught me discipline and has helped me to better grasp the world of values.

Classic Beauty
14″ × 12″
35.6cm × 30.5cm

Identify and Weave the Three Values

All three values—light, middle and dark—should work separately and together weaving throughout a painting. Only then will the darks and lights show a cohesiveness. Think of words like *linking, connecting, flowing, skating, joining* and *incorporating*. Jot down words that have meaning to you in your sketchbook. Write it big!

You must first be aware of what is to be unified. Dig in and make a series of three thumbnails to dissect and identify the value parts.

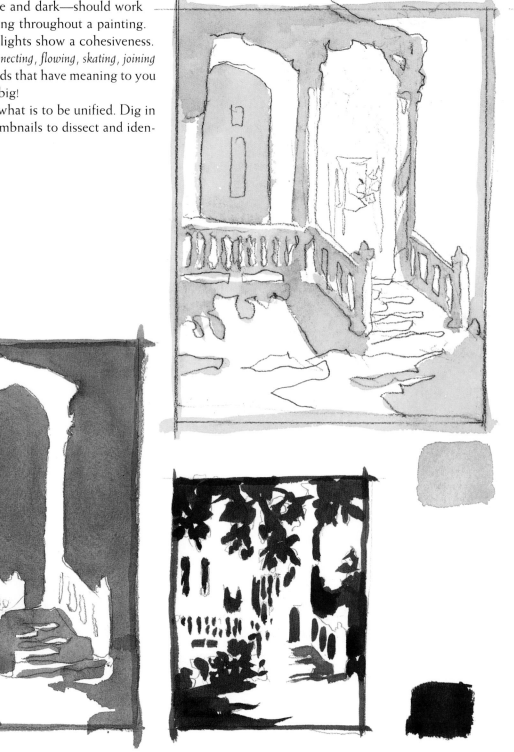

EXERCISE **Identify the Flow of Each Value**

Use one color or grays and black. Make the light, middle and dark value areas flow separately from top to bottom of your paper or vice versa. Look for each arrangement to have character, "bigness" and a pattern. The middle arrangement will usually comprise the largest area. Train your eye to see and your mind to think when viewing subjects.

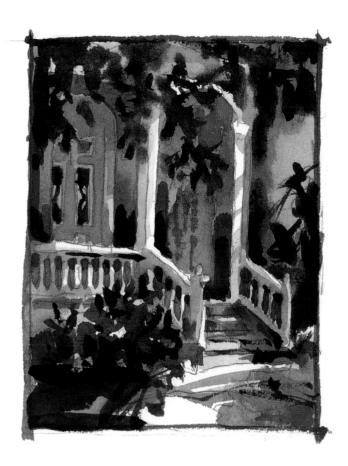

Weave the Values Together

The accumulated information is combined into a whole related value statement. This sketch contains all the knowledge needed to weave the values together for a painting.

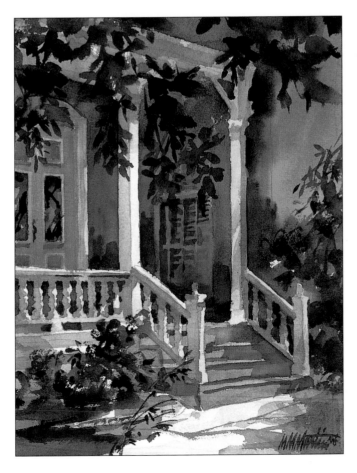

I scaled my sketch to transfer a drawing onto paper. The sketch was a guide. You can see that value adjustments were made; flexibility is important.

Victorian Mystery
16½" × 13½"
41.9cm × 34.3cm

Use the White of Your Paper

Dramatize your statement by taking advantage of paper purity as an added value. It represents your lightest value. I avoid white paint, so I use the white of my paper to enhance the value contrast and sparkle.

The following examples represent a few white paper value possibilities. You'll discover more potential uses as you paint. Just make sure the white areas are unified and hold together as a whole. It's easy to have separated whites dancing all over the paper in a disjointed arrangement. Watercolorists sometimes have a habit of falling in love with every precious white at the detriment of painting unity.

Think Value

Always keep in mind the reason for your attraction to a subject. The dark and light contrasts carved onto the paper cause the subject to breathe life.

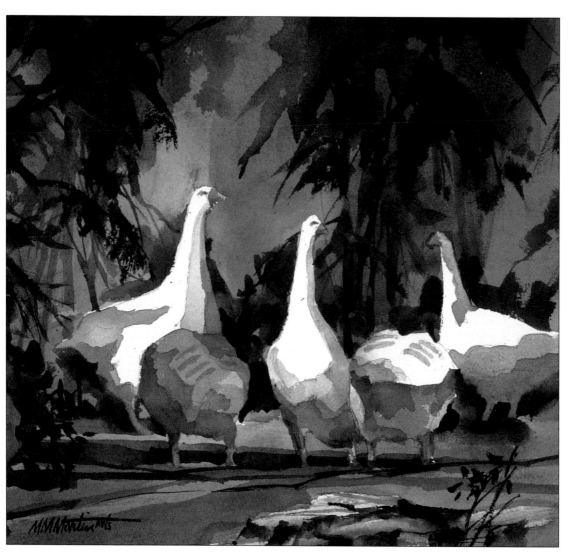

Use White Paper to Describe
A value plan helps when saving a white area. A surrounding darker value provides contrast, and makes the white value sparkle. I enjoy the energy of painting a background mass around a focus, leaving a crisp white shape. The subject, in reality, does not necessarily need to be white. You have the option to make it so.

Family Gathering
13" × 13"
33cm × 33cm

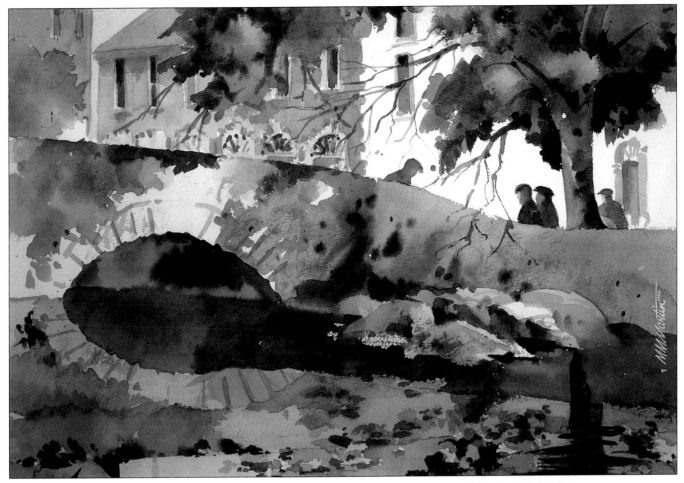

Use White Paper to Stage

Interest can be created by designing a dark object against a white area. I felt the silhouetted men would be more effective against a white wall than the actual pink wall color. The white is a bit lighter in value than the pink. Think value before color!

A Timeless Irish Tradition
15″ × 22″
38.1cm × 55.9cm

Use White Paper in a Vignette

Consider the potential of white value in the form of a vignette. A vignette is a well-placed shape consisting mostly of middle values with well-shaped and well-related dark values. It usually connects to four edges of the paper, leaving four corners of untouched white paper, each different in size and shape. Avoid too many lights in the large shape of midtones as you already have plenty of area in the white corner areas. The crisp white corners can add a dimension to your statement.

Regal Rulers
15″ × 22″
38.1cm × 55.9cm

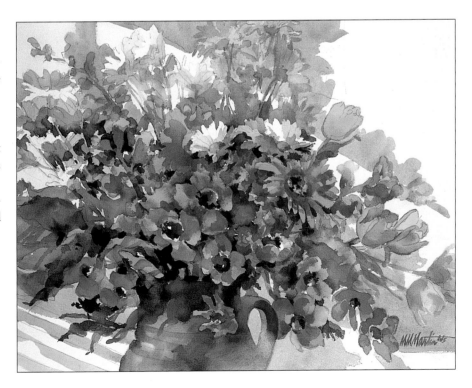

Value Creates Space

As artists, we relate to the visual environment that we know. Some of us live surrounded in vast expanse; others live in very compact space. We naturally conceive of depth of space differently. Our paintings will incorporate our vision and feel for space.

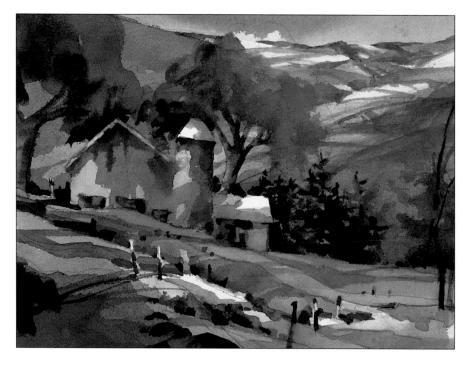

Unlimited Space
The strong contrast of dark to light creates space and motivates the eye from foreground into background. The more the landscape areas are subdivided into dark and light planes, the greater the illusion of distance.

Limited Space
The space in this version is contained. Close value contrast in the foreground suggests limited space. An enlarged focus area decreases the surrounding space.

Think Value

- Use white paper to describe your focus.

- Use white paper to stage your focus.

- Use white paper in a vignette design.

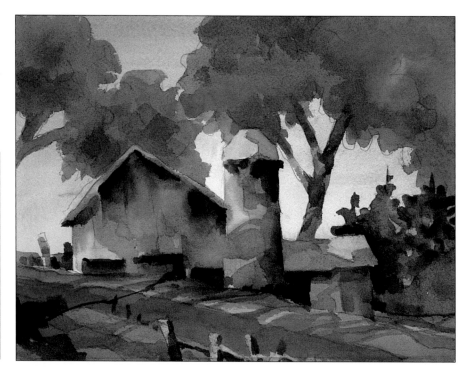

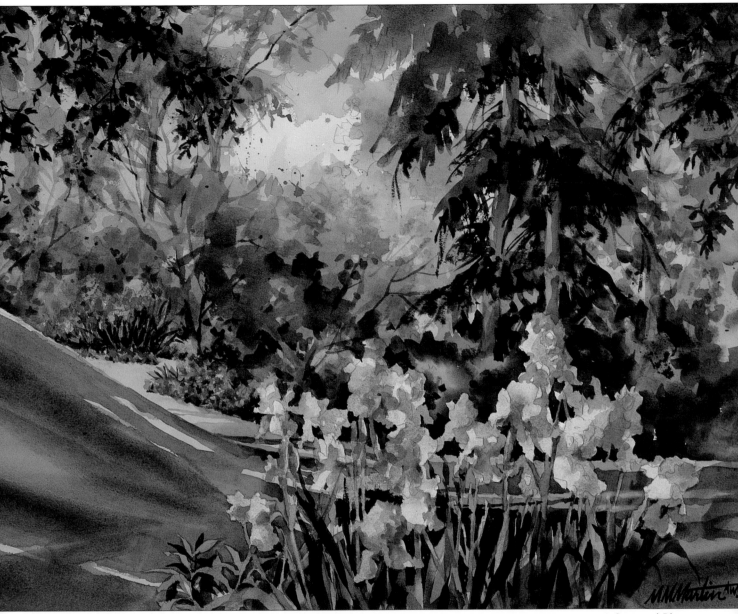

The beautiful old trees with exquisite dancing shadows of contrast provide a dramatic setting for solitude and replenishment. I have known this place very well all my life. I enjoy wandering the terrain, breathing the fresh air and marveling at nature's showmanship.

A Space and Place
22" × 30"
55.9cm × 76.2cm

Value Creates Mood

You have the power to create mood. Value range and the amount of value contrast are vehicles available to suggest mood. Follow along as I paint three versions of mood—low-key, high-key and middle-key statements of a similar subject.

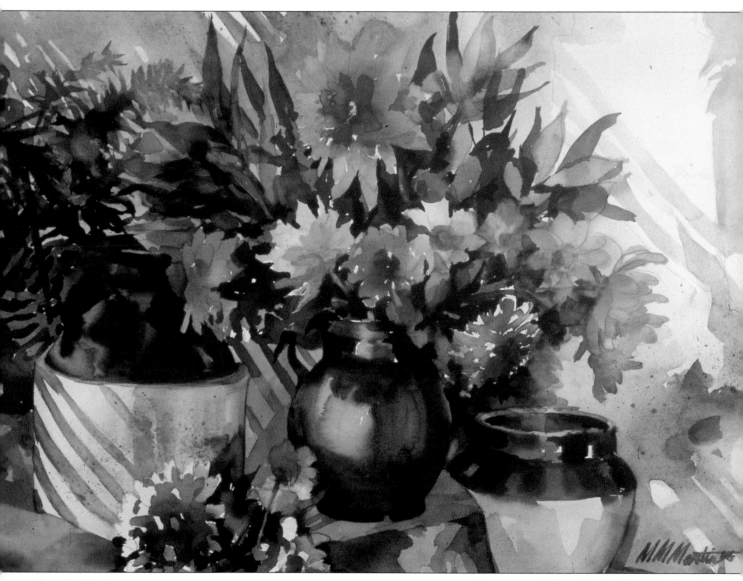

Low-Key Version
Much of the painting is darker than middle value; there is contrast. Saved light areas are surrounded with rich darks. The focus is directed to the lights. The mood is theatrical.

Studio Sunlight and Shadow
22" × 30"
55.9cm × 76.2cm

Exercise

Select a subject you like—one that suggests feelings of melancholy, turmoil, happiness—and create several versions of mood by manipulating the value range and contrast. One subject can suggest many paintings.

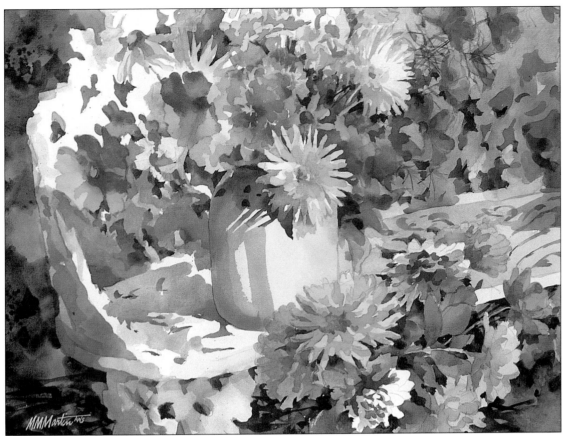

High-Key Version

Most of this version is lighter than middle-value range. Darks are limited. The contrast is considerably less than in the low-key translation. The mood is light and happy.

Gala Splash
22" × 27"
55.9cm × 68.6cm

Middle-Key Version

Most of this statement is within the middle-value range. Value contrast is limited; color is the vehicle for creating contrast. Space is limited. The mood is joyous, cheerful and upbeat.

Flamboyant
14" × 16"
35.6cm × 40.6cm

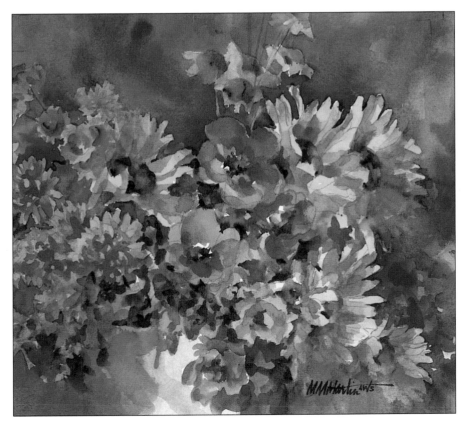

Create Drama With Value

While teaching a workshop in Beaufort, South Carolina, I discovered a rich treasure of visual vitality. It was while meandering on my own through the quiet streets that I felt and saw the spirit and beauty. Stage settings were everywhere! It was definitely the strong contrasts of crisp lights and rich darks that created the theatrics and inspiration. Every glimpse was an encore! One needs to take time to see in order to respond with enthusiasm and energy.

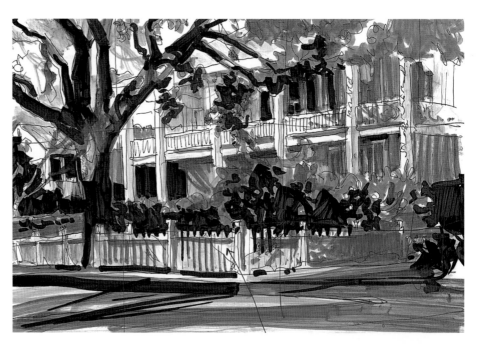

STEP ONE

Exploration

Let's begin by creating a number of value sketches on location. These can be used in the studio at a later time. Take photos, but plan to spend some quiet visual time in the environment. This experience can't help but add "heart" to your painting—besides, it's fun! If your values are in the ballpark, any color selection will "work." These sketches will provide you with a wealth of genuine information. Immerse yourself with the sights, sounds and smells! Look particularly at the value contrasts and try to see within the darks.

Organize your thinking, we'll be encountering a white structure and fence showcased against a dark tree and foliage. The primary focus will be

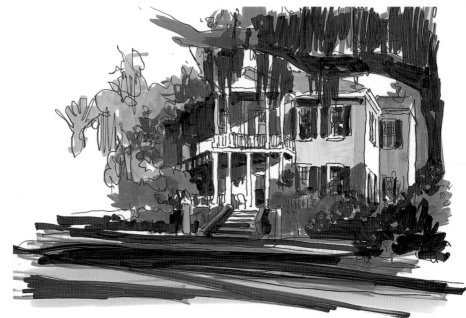

the light areas on the structure. It is the lightest lights against the darkest darks that will provide the spark in this painting. Be aware that shadows on white might be middle value or darker. It will probably be darker than you think. Half close your eyes to evaluate the contrast.

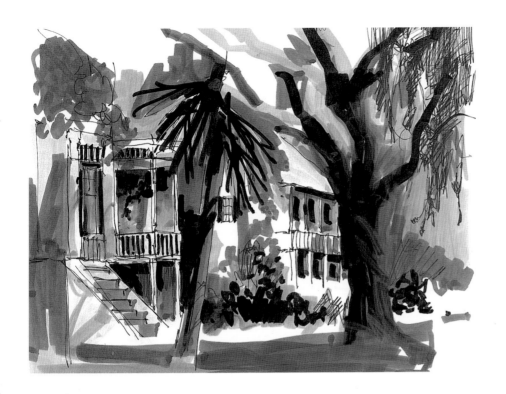

Location Value Sketches

Any of these sketches could evolve into a painting, and will definitely be used for reference at a future time. I enjoy using a felt-tip pointed pen for line work, and laying in values with gray chisel-point markers. It's a quick way to state values. If you feel more comfortable with pencil or charcoal or one color of watercolor, use it! The process and information is more important than the medium.

At this moment, my enthusiasm gravitates to the intimacy and containment of the sketch to the right, so let's go with it!

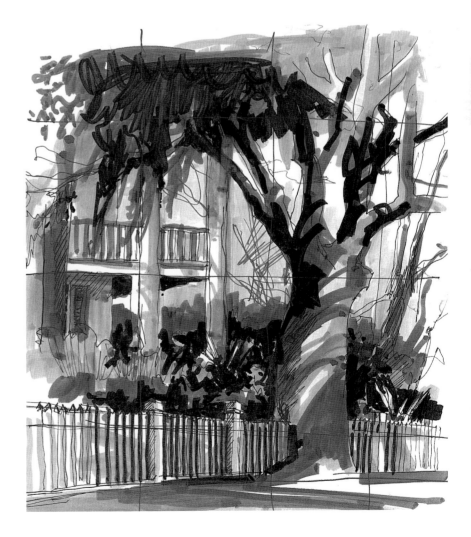

STEP TWO

Pencil Drawing and First Wash

Create a pencil drawing on a full sheet of 300-lb. (640gsm) Arches cold-press paper. It is useful to draw a scale of vertical and horizontal lines on the value sketch to help recreate an approximate enlargement on the paper. A corresponding scale is created on the watercolor paper. I changed the perspective slightly from the original sketch, and adjusted the light and dark values to achieve a more organized focus.

Remember . . . a blank sheet of white paper always has unity. We will add variety without destroying the unity.

You can use push pins to attach the paper corners to an angled board. Remove the sizing from the paper with a sponge and water, and allow the paper to dry.

With a 1¼-inch (3cm) flat brush, wash over most of the paper with a pale value of Winsor Yellow and Grumbacher Rose Madder Hue. When dry, this gives the whites and lights a warm glow. After drying, add light Winsor Blue (Green Shade) mixed with a bit of Winsor Green (Blue Shade) to the sky area. Paint around the tree trunk to achieve color freshness in the end.

Think Value

Watercolor paper is flat. The relationship of dark to light values creates the illusion of expanse. Do you want to portray unlimited space, a confined distance? Your painting subject should live and breathe in some definition of space.

- Close value contrast creates limited space.
- Wide value contrast creates unlimited space.

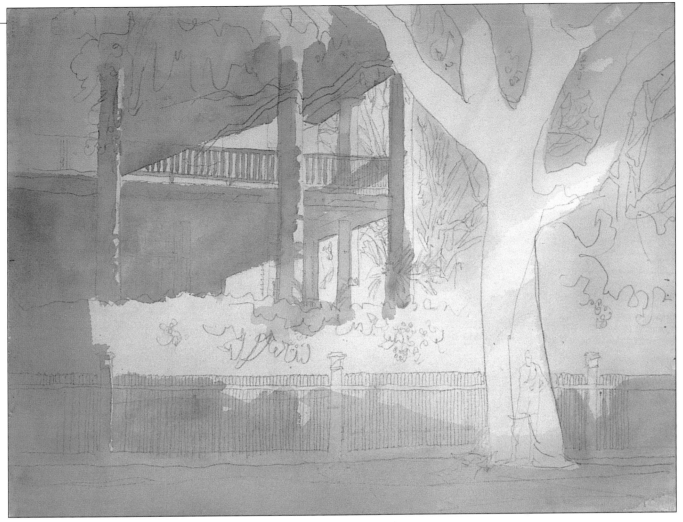

STEP THREE

Shadows

Achieve unity by connecting big abstract shapes when laying in shadow areas. I get nervous about going as dark as I know I should. After all, a light value will appear dark when compared to white paper. I'm more confident to lay in a light value, so . . . let's go for it! Shadow on the structure merges into shadow on the fence into foreground.

Remember . . . we're not painting things; we're painting the passage of shadow.

Let's aim for color luminosity—a light value of Winsor Green (Blue Shade), French Ultramarine, Cobalt Violet, Rose Madder Hue and New Gamboge on dry paper and leave alone. These are my color choices. You use your own; the value is the key.

Value on White

Let's pretend we're looking at a black-and-white photograph. Translate on a scrap of watercolor paper light, middle and dark values for the white structure shadow. Color is your choice. Our only concern is light, middle and dark values. I chose: French Ultramarine, Burnt Sienna, New Gamboge, Winsor Orange, Cobalt Violet, Rose Madder Hue, Purple Madder and Winsor Green (Blue Shade). If the values are similar, any number and variety of colors will "work." The dark values have more pigment and less water than light values.

Light　　　　**Medium**　　　　**Dark**

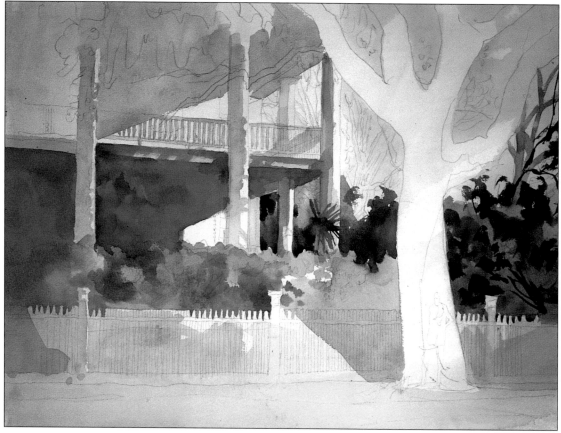

STEP FOUR

Lay in Darker Washes

Because the darks are so important to this subject, let's jump into these now to help suggest a relationship of space. Besides, I can't wait! We should have confidence to lay a darker wash over the original light shadow of the porch. When dry, pencil lines can be seen.

Light falls across the top of the front foliage, so New Gamboge mixed with Winsor Green (Blue Shade) and Burnt Sienna, Cobalt Violet and Permanent Rose take care of this mass. Add additional pigment in the dark areas while damp. We begin with light value and merge into middle value.

Green Values

Be aware of the foliage value contrasts. Make swatches of a light, middle and dark green. Again, color is irrelevant; it is the intensity of light to dark that is important. This knowledge contributes to a security that allows you to use the medium with directness. You control the medium!

Light

**Winsor Green
(Blue Shade)
and New Gamboge**

Middle

**Winsor Green
(Blue Shade)
and Burnt Sienna**

Dark

**Winsor Green (Blue
Shade) and Permanent
Alizarin Crimson**

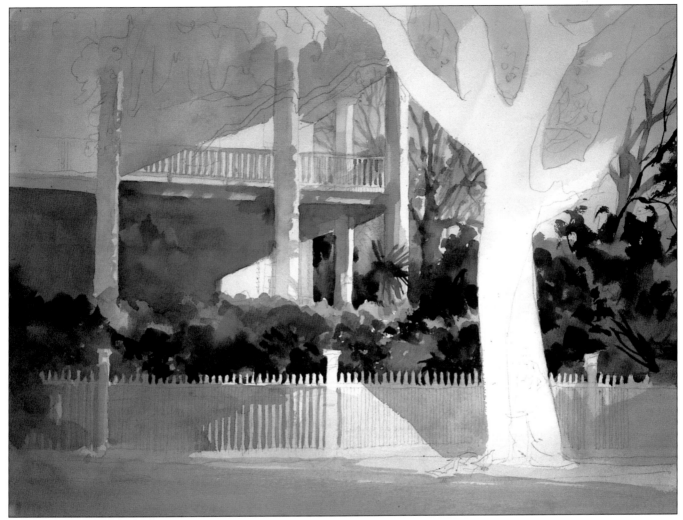

STEP FIVE

Lay in a cooler wash of French Ultramarine, Purple Madder and Cobalt Violet on the fence and foreground. Darker accents of Winsor Green (Blue Shade) plus Burnt Umber and Winsor Green (Blue Shade) plus Permanent Alizarin Crimson are added for extreme dark. These values punch out fence detail.

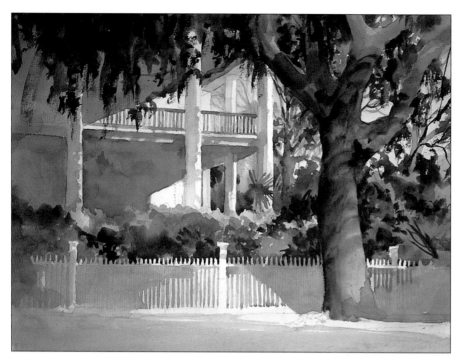

STEP SIX

I purposely avoided the dark tree. Darks have a way of becoming very "dead," and they will usually be more opaque than lights. Let's keep the dark as luminous as possible. Lay in a light value of Rose Madder Hue and Cobalt Violet, pull in Winsor Blue (Green Shade) and Winsor Green (Blue Shade) and add French Ultramarine and Burnt Umber toward the top paper edge. Wait a minute or so, and while still damp, lay in a dark value with lots of pigment and only enough water to make the mixture flow. Purple Madder and French Ultramarine as well as Permanent Alizarin Crimson with Winsor Green (Blue Shade) provide snappy, rich dark values.

STEP SEVEN

As soon as life—such as a person or birds—are added to a scene, the eye will gravitate to them. Try keeping the values and color subdued, and the life becomes a secondary interest. Remember, save the strongest contrast of light and dark for the limelight.

Place a work mat on the painting, then step back and take a break. Fresh eyes will be invigorating.

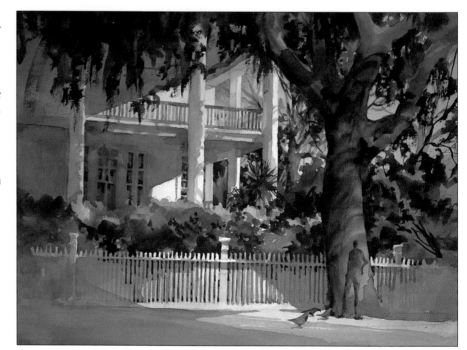

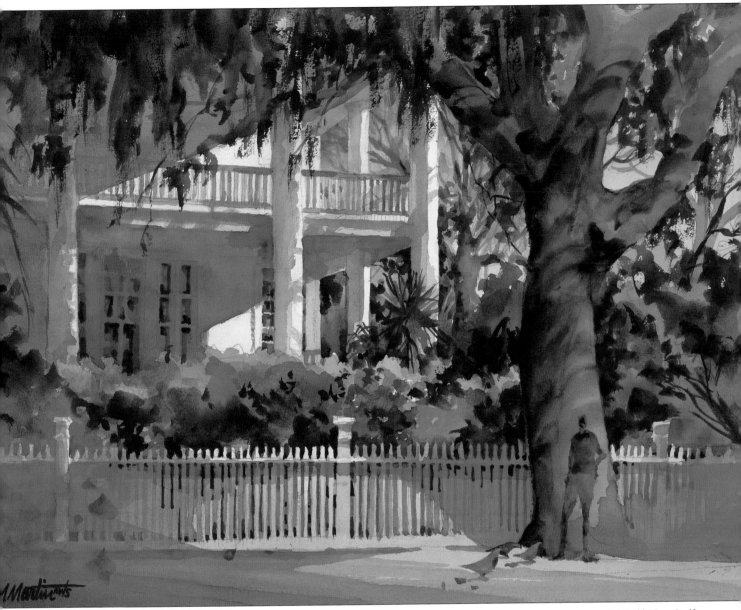

STEP EIGHT

Like a stage curtain framing the set, darker foliage on the left side helps contain the focus. Additional darks are added and continued over the foreground. Further glazing of colors and values will destroy the charm and lose the fresh, crisp watercolor quality. The statement has been made!

A World Unto Itself
22" × 30"
55.9cm × 76.2cm

Create Drama With Color

Color is individual, descriptive and uplifting—an emotional performer. It can be objective, subjective or anywhere in-between. It can be exquisitely subdued or powerfully theatrical. It has value and can create mood and mystery.

Color and Value Create Mood

Color's role is to create and enhance a mood. Create an atmosphere with color that's in touch with your own inner energy. Think of words that best express your reactions, then select colors that relate to your words. Convey that feeling with complete honesty and integrity. Be true to yourself!

If you want to show restraint, use similar values and quiet neutral colors. If you prefer to shout your feeling, go for strong light and dark contrast against crisp, rich, vibrant color. You have the power to create loudness or softness. The key is to get in touch with your inner feelings.

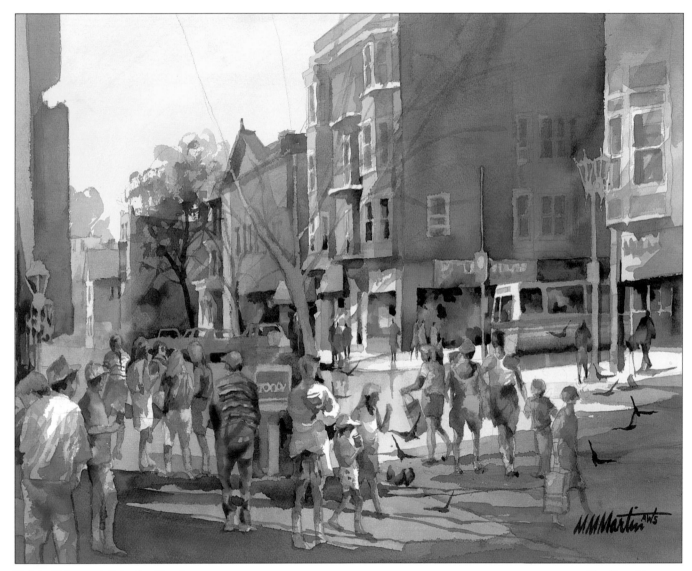

Relate Value and Color for Mood

This setting is an everyday encounter for me. The people change, but the architecture stays! The temperature and mood of the day here is warm and sultry. After a careful pencil drawing on the paper and time for people observation, I choose a warm light value peach color to cover most of the paper. Color dominance and unity are immediately achieved, and a mood is established. Squint, and you'll see that this is primarily a value painting—the dominance of one color in a full value range. Blue accents stimulate variety. Color and value go together.

Allen Street Design
22" × 30"
55.9cm × 76.2cm

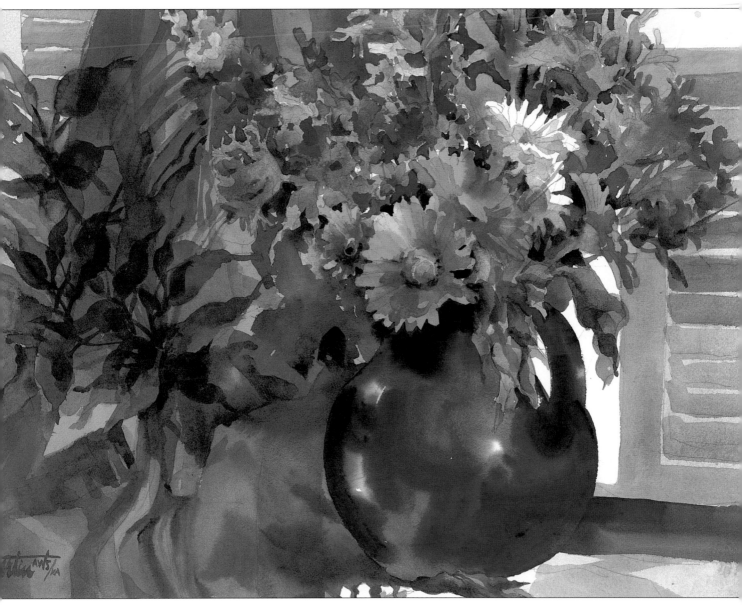

Relate Words to Color for Mood

This subject was one of many setups at my annual studio Spring Festival floral workshop in Buffalo. I wanted to shout enthusiasm—*assertive, effervescent, vigorous, energetic* and *bold* were my word responses. Words can suggest color, and color can suggest words. Keep conversation among colors alive. No question, the colors are intense and pure. The value range is extreme—white paper to rich darks. The mood is authoritative. Find a subject that you like, relate your words to the colors, and capture a dramatic mood and statement.

Positively Fiesta
22″ × 30″
55.9cm × 76.2cm

Think Color

- Color has value.

- Color has energy—intense or muted.

- Color has temperature—warm or cool.

- Color is relative to those colors next to, opposite or around the color wheel.

- Color can be objective, subjective or in-between.

- Color can create mood and mystery.

- Color is particular and personal.

Color Fundamentals

A color wheel is one of many ways to see and know color. You probably know red, yellow and blue are primary colors; orange, green and violet are secondary colors. Each color is relative to the color next to, around and opposite it on the wheel. Opposite colors on the wheel are referred to as *complements*. Complements are red and green, blue and orange, yellow and violet. Adjacent colors on the wheel are known as *analogous*. Yellow, orange and red suggest analogous color; so do green, blue and violet. There are warm and cool versions of each color. Color can be grayed or neutralized by adding its complement.

Transparent Staining Pigments

I enjoy using transparent staining pigments. Some artists are fearful of their strength, but that's exactly what creates rich theatrics and keeps a painting from obtaining a chalky appearance. I like the authority, intensity and transparency they create. Select colors that create a positive response from you, and familiarize yourself with all their possibilities.

Translate Value to Color

Color now takes the lead with value as support. As with the simplified gray value chart in the previous chapter, be secure in knowing the light, middle and dark value for each color included in your palette.

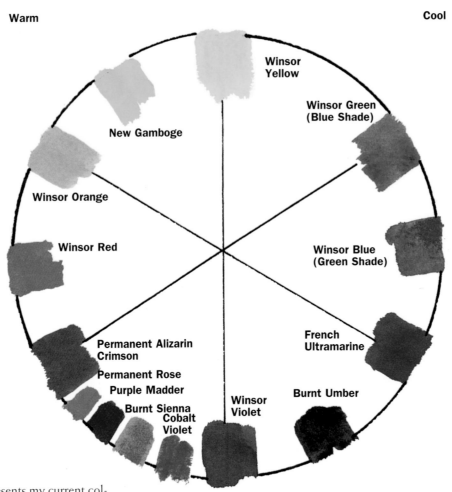

Warm

Cool

Winsor Yellow

Winsor Green (Blue Shade)

New Gamboge

Winsor Orange

Winsor Blue (Green Shade)

Winsor Red

Permanent Alizarin Crimson

Permanent Rose
Purple Madder

Burnt Sienna
Cobalt Violet

French Ultramarine

Burnt Umber

Winsor Violet

This color wheel presents my current colors and helps me organize my color logic. It provides support when I ask myself, "Do I want to use a dominance of analogous color?" or "Do I want a dominance of complementary color?" To fully understand, create your color wheel using the colors on your palette.

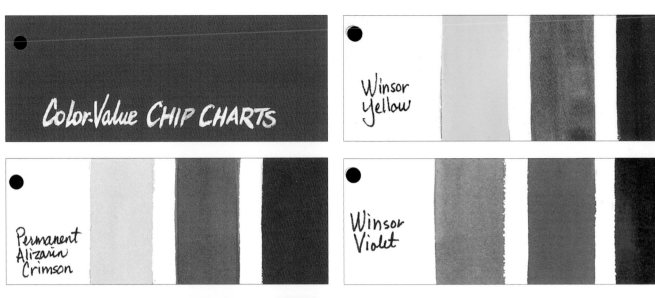

Color-Value CHIP CHARTS

Winsor Yellow

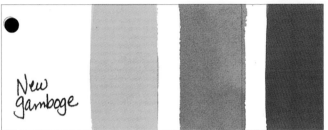

Permanent Alizarin Crimson

Winsor Violet

New Gamboge

E X E R C I S E Make a Color-Value Chip Chart

I suggest taking the time to create a chip chart for each one of your colors. Some examples of mine are shown here. Strike in a light, middle and dark value of each color. Watercolor dries lighter, so apply pigment boldly. Keep these individual chip charts together, and nourish for your painting reference. This collection can be a tool and guide for gauging how dark or light you need to go. The aim is for direct, clean color in the correct value. You learn and understand only by doing!

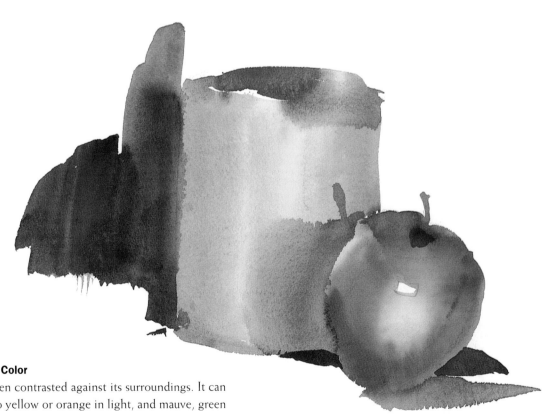

Be Free With Your Color

Red is only red when contrasted against its surroundings. It can appear red, but also yellow or orange in light, and mauve, green or brown in shadow. You learn how color works only by painting. Make many similar studies. Place a spotlight on your favorite fruit or vegetable. Don't worry about subtleties. Let your paint merge! The rich dark mass makes the lightness glow.

Another Way to See Color

There are countless theories and approaches to color. My approach is to grasp the fundamentals, then turn to nature's artistry. To be honest, just about everything I have learned and continue to absorb concerning color has come from planning, observing and working in my gardens. As I'm talking to you, a particular corner presents a vibrant red mass drenched in brilliant sunlight. A magenta and violet mosaic crowd behind reflects distinct purple shadows on the red—electric vibrations! I never noticed that before. Take time to encounter. You can discover a color feast right outside your door.

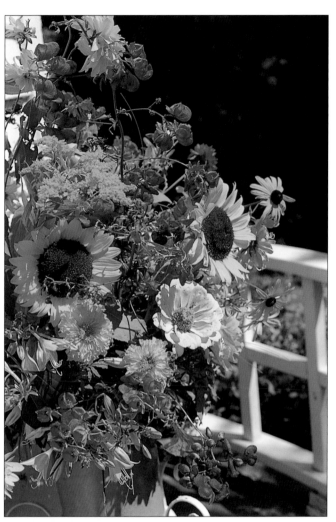

Explore Complementary Color

For maximum color contrast, I enjoy gathering a lush garden collection in complementary colors; in this case, yellow and violet. I search for cool and warm versions of a color, such as the warm yellow sunflowers and the cool yellow zinnia. Violets can be blue-violet and red-violet. Don't be afraid to look for exaggerated variations. This information can be applied to any subject. The important thing is to observe the reality. This live gathering was the subject for several paintings.

Explore Analogous Color

I plan mosaic masses of warm yellows with yellow-oranges, oranges and reds in my garden. Learn that color can be manipulated to your own liking, and that light creates color. I love the dynamic vibrations; your taste will be different than mine. Be individual with your exploration of analogous color!

Explore Color as Value
I plan a niche around one primary color, and attempt to show a number of variations—a color statement in value. Think light, middle and dark values; think warm and cool colors. Notice that warm and cool versions can be intermixed and combined in nature. It can work in a painting.

Think Color

Color, whether vivid or muted, analogous or complementary, warm or cool, is all around you. It's reflected in your clothing and home. If you feel insecure with it, I suggest you surround yourself with quality decor publications. Study the colors and the color relationships, not the things. Open your eyes and mind to theater stage settings, window and store displays, master paintings, gardens, sunrises and sunsets. All of us need to nurture inspiration. Look at images as color. Personal taste will gradually develop and expand. Don't be vague. See color freshly and directly. It should have an identity and it should be you.

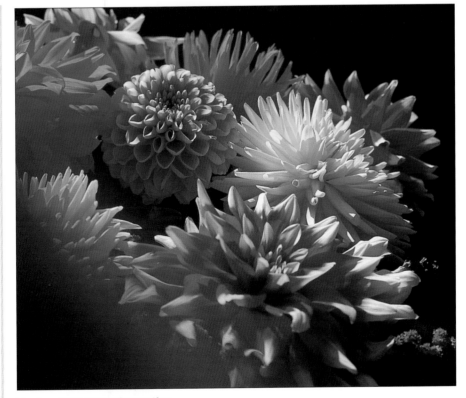

Explore Rich Color Saturation
Not only do I marvel at the structure of these dahlias, but the rich color saturation in light and shadow is an inspiration for dramatic color in a painting. Much can be learned from nature!

Every Color Has Temperature

Color temperature is relative and determined by comparing color to color. There can be no warm color without cool; there can be no cool color without warm. One's eye first gravitates naturally to warm color, whether in a painting or nature. Strive for temperature dominance. When in doubt, head for the warm tones. For transparent results, it's best to lay a cool glaze over a warm wash rather than the reverse. Warm color tends to step forward, cool color recedes. But all of us know that rules are made to be broken; it's fun to do so and make it work—always keep the option open!

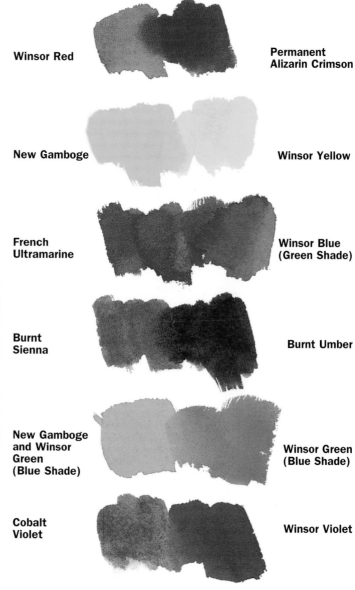

Warm **Cool**

Winsor Red — Permanent Alizarin Crimson

New Gamboge — Winsor Yellow

French Ultramarine — Winsor Blue (Green Shade)

Burnt Sienna — Burnt Umber

New Gamboge and Winsor Green (Blue Shade) — Winsor Green (Blue Shade)

Cobalt Violet — Winsor Violet

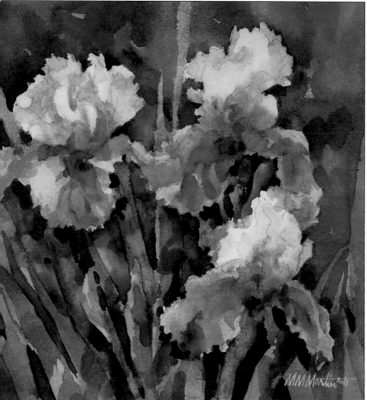

Pure complements—yellow and violet! It's the strong value of the violet background that stages the drama of the yellow complement. Use color as a point of departure. Look for temperature variety—a cool yellow-green versus a warm yellow-orange in the petal; a warm red-violet compared to a cooler blue-violet in the background area. A spark of warm orange is purposely charged in the yellow to create focus and energy. You want to discover color, not draw attention to it. Think of color as an opportunity to unify the whole as indicated in the mauve foliage shadows. Background, flowers, stems and leaves all go together.

Iris Complements
11" × 11"
27.9cm × 27.9cm

Warm vs. Cool

Greens and blues are considered "cool" on the color wheel, but there are warm and cool versions of each. Yellow is generally thought of as "warm," but there are cool and warm tones. Experiment with colors on your palette so that you have a comfortable understanding of the differences. After a while, you will freely intermingle both without thinking about it.

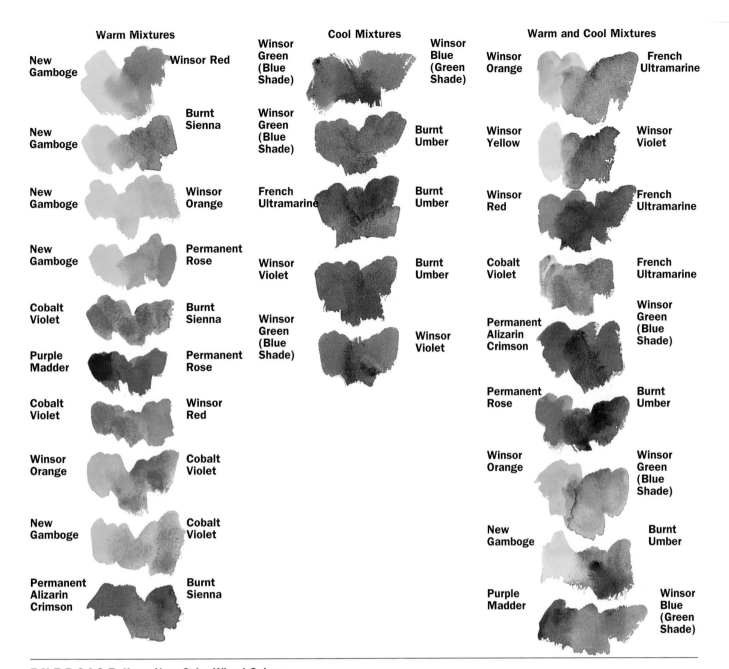

Warm Mixtures

New Gamboge / Winsor Red

New Gamboge / Burnt Sienna

New Gamboge / Winsor Orange

New Gamboge / Permanent Rose

Cobalt Violet / Burnt Sienna

Purple Madder / Permanent Rose

Cobalt Violet / Winsor Red

Winsor Orange / Cobalt Violet

New Gamboge / Cobalt Violet

Permanent Alizarin Crimson / Burnt Sienna

Cool Mixtures

Winsor Green (Blue Shade) / Winsor Blue (Green Shade)

Winsor Green (Blue Shade) / Burnt Umber

French Ultramarine / Burnt Umber

Winsor Violet / Burnt Umber

Winsor Green (Blue Shade) / Winsor Violet

Warm and Cool Mixtures

Winsor Orange / French Ultramarine

Winsor Yellow / Winsor Violet

Winsor Red / French Ultramarine

Cobalt Violet / French Ultramarine

Permanent Alizarin Crimson / Winsor Green (Blue Shade)

Permanent Rose / Burnt Umber

Winsor Orange / Winsor Green (Blue Shade)

New Gamboge / Burnt Umber

Purple Madder / Winsor Blue (Green Shade)

EXERCISE Know Your Color Wheel Colors

Try mixing all your warm color wheel colors with each other, then all your cool colors with each other, and then intermix cool with warm. These are a few of my possibilities. There are more. Try mixing your colors.

Think Color

Use the finest professional colors for better handling, better permanency and stronger saturation. It is essential to have an abundance of usable squeezed pigment on your palette. Rich color intensity is simply not possible with old dried-up paint. Don't be frugal! Begin with a lot of clean pigment, a clean mixing area and clean water.

Blend Colors of the Same Value

A painting area is unified if values of the colors are similar. Too much water will make color lack richness. Get to know the right ratio of water to pigment for the right consistency of paint. That simply takes time, practice and patience. I make swatches similar to these before beginning every painting. It's part of the creative color process.

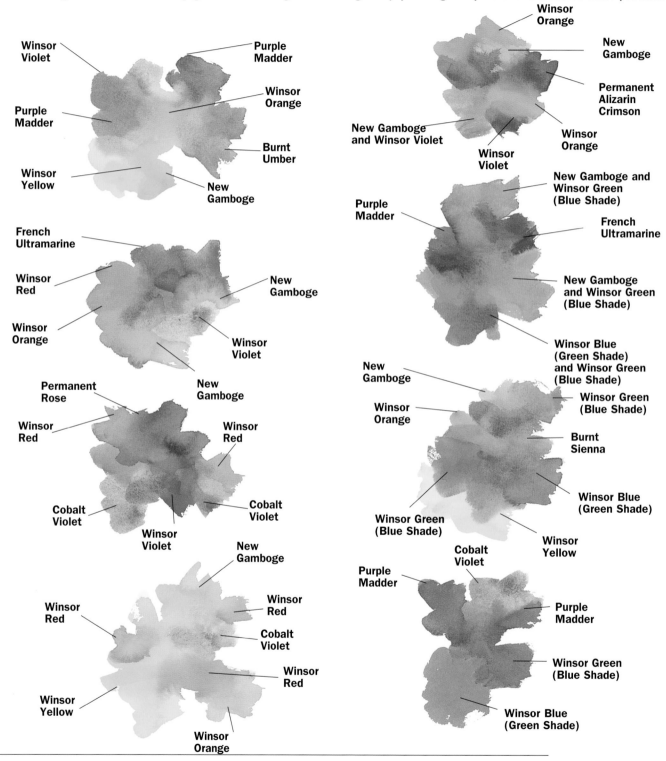

EXERCISE Similar Value, Different Color
Mix and blend a range of colors on a dry paper surface. Let the medium work for you by allowing pigment and water to merge. Partially mixed colors are often more interesting than thoroughly mixed colors.

Blend Colors for Luminous Darks

Darks can have luminosity and atmosphere. Darks are naturally more opaque than lights, but you should still be able to see into them. Give them life and air; they will dramatize and reinforce your lights.

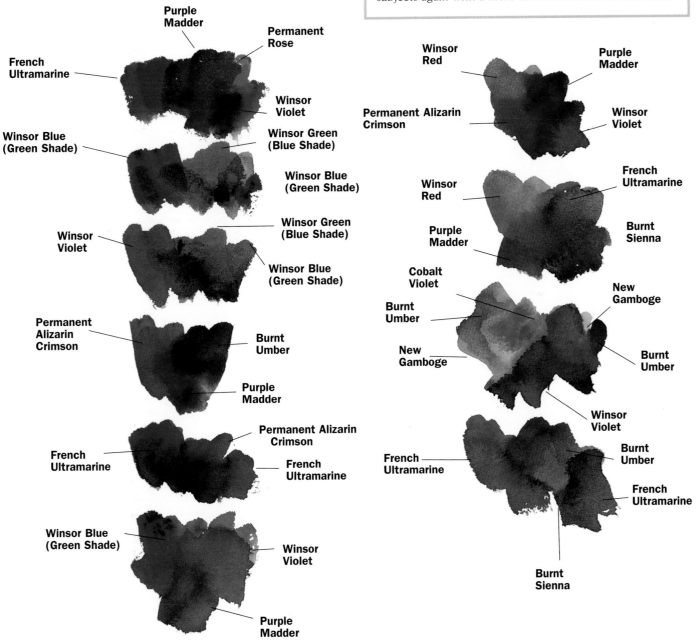

EXERCISE Rich, Saturated Dark Color

Don't be timid! It is these rich darks contrasted with luminous lights that inject drama into your work. A two-color mixture will be more transparent than three or four colors. Many colors can be used if the values are similar and colors are injected on your paper.

Neutral Tones Set the Stage for Color

Neutral tones are nonpartisan and nonconflicting. They counter-balance and complement brilliancy and are vitally relevant in your repertoire of colors. They are the supporting cast, and are needed to make brilliant color the hero. Both react and respond to one another.

Color needs variety, otherwise monotony dominates.
• Muted color dominance needs color variety to make it shine.
• Intense color dominance needs muted color to make it shine.

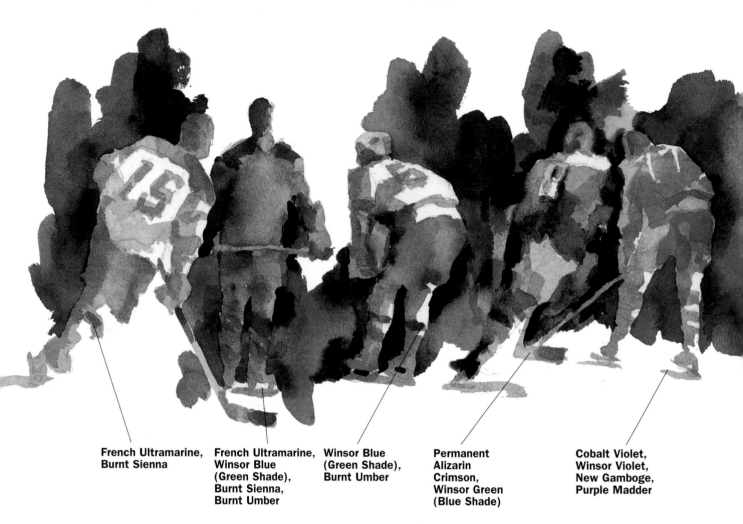

French Ultramarine, Burnt Sienna

French Ultramarine, Winsor Blue (Green Shade), Burnt Sienna, Burnt Umber

Winsor Blue (Green Shade), Burnt Umber

Permanent Alizarin Crimson, Winsor Green (Blue Shade)

Cobalt Violet, Winsor Violet, New Gamboge, Purple Madder

EXERCISE Create Neutral Tones

Become familiar with mixing neutral color. I don't use a formula. I prefer to be inventive; but to begin let's try a few basic combinations, and let your inclinations take over. Your subject and situation will suggest possibilities. Neutral tones can be light, middle or dark value, as well as warm and cool. Every time you touch a wet neutralized mixture, you dull the result. Aim for direct application of color to achieve fresh luminosity.

Neutral color should never be lifeless; it should be color that is rich and luminous, though subdued. The drama is created when surrounded with rich, dark saturation. Blue and brown are near complements and cancel each other if mixed equally. Begin with pure French Ultramarine, charge in Burnt Sienna, and a warm neutral tone is created. Be sure to indicate some pure color for zip. Winsor Blue with Burnt Umber suggests a cooler neutral color. Experiment with complementary combinations such as green and red, yellow and violet, etc.

It's the grayed tones that make the rich colors glow. Think of neutralized tones for less important parts of your painting. Consider them for negative spaces or for distance. In this painting, the neutralized shades create intimacy as well as containment. A complementary mixture of red and green, along with the addition of adjacent colors, presents a luminous neutralized mass. Merge these colors on dry paper and leave alone to dry.

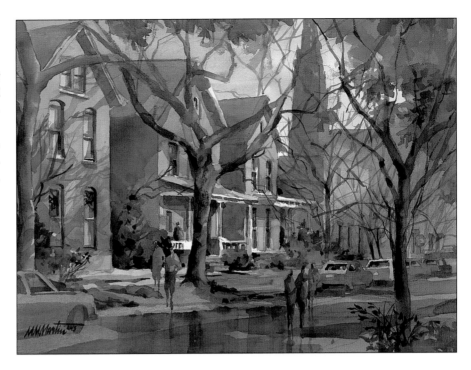

Allentown Glow
22″ × 30″
55.9cm × 76.2cm

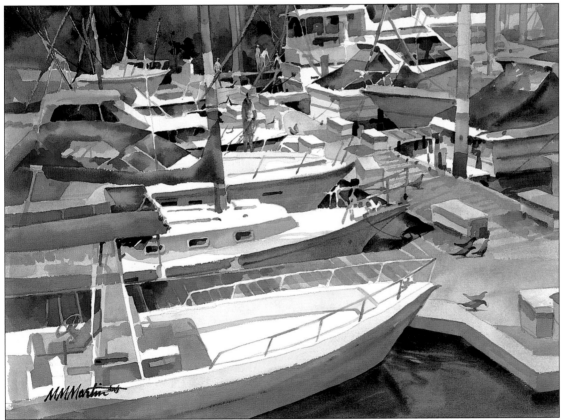

In this painting, it's the spot of rich, unexpected color that helps make the neutral color sparkle. Luminous tones and a limited palette of blues and violets are the dominant color players. It's the spot of red in the background that breaks the monotony. It's the artist's responsibility to make the viewer's meandering efforts worthwhile. Color can be conceived as imagination and used as the punch at the end of the journey.

Nautical Design
22″ × 30″
55.9cm × 76.2cm

Create Drama With Color

I've always loved anemone. Matisse liked to paint their dark centers; I'm attracted to their radiant petals in reds, purples and magentas. Color is personal. I gravitate to rich jewel tones. Color gives me an opportunity to express freedom, surprise, exhilaration and wonder. It's a celebration!

I unexpectedly came upon these anemone in a florist shop, added a few white daisies and baby's breath for variety, and anxiously returned to my studio to go for it! It is the color that excites me!

I explore the particular anatomy by making several line drawings with a pencil or felt-tip pen in my sketchbook to understand the structure. Search for the contour and then the individual petals. Gravitate to different views.

STEP ONE

Exploration

In order to handle your media with confidence, you need to become acquainted with your subject and establish a game plan. Open your eyes to really look at the subject. Understand the artistry and anatomy of the flower structures. Do they grow in graceful curves, or are they stiff and straight? Do the blossoms normally face up, or down, or both? What is the character of the foliage?

Think and plan the big arrangement. A small contour drawing in my sketchbook is surrounded with a dark background indication. Envision a big abstract shape and attempt to make the non-subject areas into interesting shapes. Think about using the paper edges. My focus is the bouquet, so I want it to fill at least three-fourths of the paper.

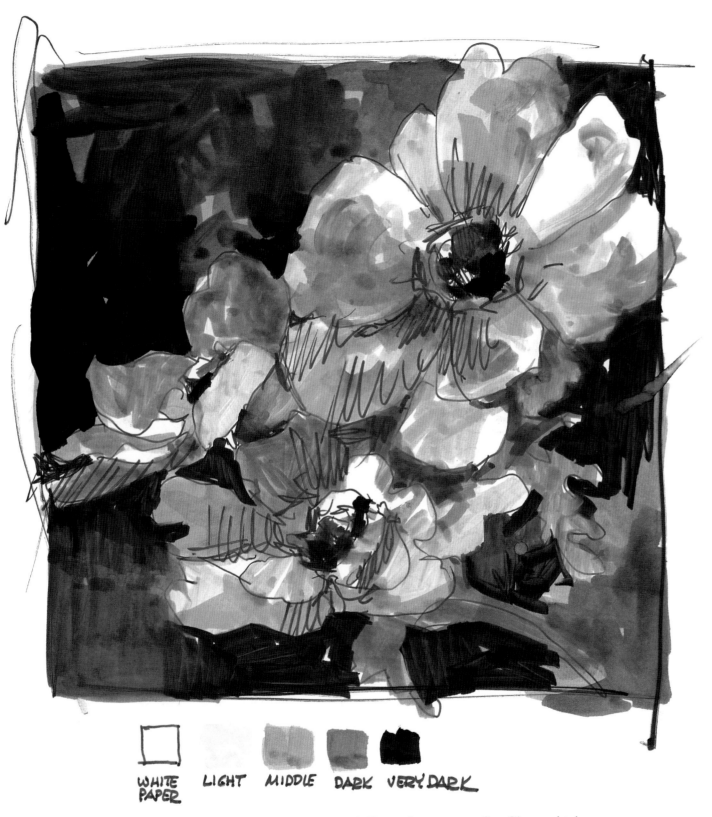

WHITE PAPER · LIGHT · MIDDLE · DARK · VERY DARK

Understand that some petals recede and others thrust forward. Flower shapes are not flat. Observe this by seeing color as light and dark—I use gray markers to help me see this. A background is important to think about at this point, as it will actually be more important than the subject. My concept is to be dramatic and present a strong, bold statement, so I choose a dark background. I don't consider color at this stage; only value.

STEP TWO

Establish a Game Plan for Color

Breaking it down, we'll primarily encounter reds and purples, green foliage, shadows on white and a background color in this painting. I select a dark blue Winsor & Newton French Ultramarine with a few value interruptions for the background. Blue is color-related to the subject as red and blue mix to purple. Personal taste also enters into the decision. Explore the possibilities before touching your watercolor paper.

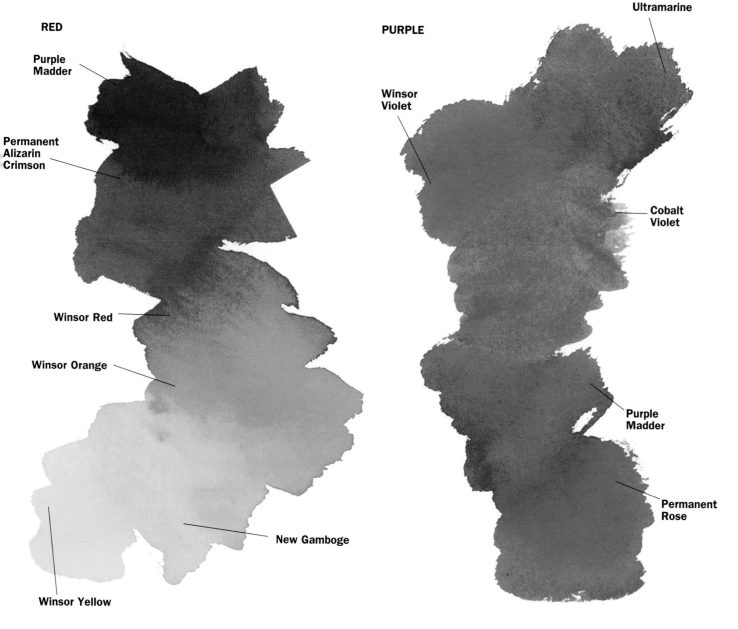

RED

Purple Madder

Permanent Alizarin Crimson

Winsor Red

Winsor Orange

New Gamboge

Winsor Yellow

PURPLE

French Ultramarine

Winsor Violet

Cobalt Violet

Purple Madder

Permanent Rose

Let's take one red anemone. On one-eighth of a sheet of dry watercolor paper, merge swatches of analogous pure color . . . Winsor & Newton's Purple Madder into Permanent Alizarin Crimson into Winsor Red into Winsor Orange into New Gamboge into Winsor Yellow. This exercise gets me thinking about light and warmth on my subject, which will give it dimension as well as vitality. Begin to think the language of watercolor.

Now take a purple anemone, and merge swatches of analogous pure color . . . Winsor & Newton's French Ultramarine into Winsor Violet into Cobalt Violet into Purple Madder into Permanent Rose.

GREEN

Winsor Green (Blue Shade) and New Gamboge

Winsor Green (Blue Shade) and Winsor Yellow

Winsor Green (Blue Shade) and Burnt Sienna

Winsor Green (Blue Shade) and Burnt Umber

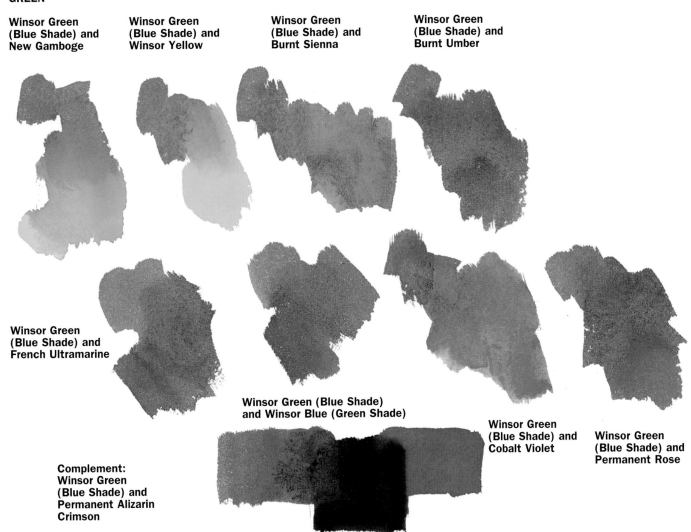

Winsor Green (Blue Shade) and French Ultramarine

Winsor Green (Blue Shade) and Winsor Blue (Green Shade)

Winsor Green (Blue Shade) and Cobalt Violet

Winsor Green (Blue Shade) and Permanent Rose

Complement: Winsor Green (Blue Shade) and Permanent Alizarin Crimson

Green must be considered, as flowers would not exist without stems and leaves. What are the possibilities? Let's try Winsor & Newton's Winsor Green (Blue Shade) mixed with each one of the following: New Gamboge, Winsor Yellow, Burnt Sienna, Burnt Umber, French Ultramarine, Winsor Blue (Green Shade), Cobalt Violet and Permanent Rose. Red is the complement to green, so Permanent Alizarin Crimson and Winsor Green (Blue Shade) will give a very rich dark.

Take Your Time

This exploration process takes a bit of time. It's a process I enjoy and find necessary to get into the watercolor flow of pigment and water. Don't be in a big hurry to apply paint to paper. I promise you that this preparation pays off in the end.

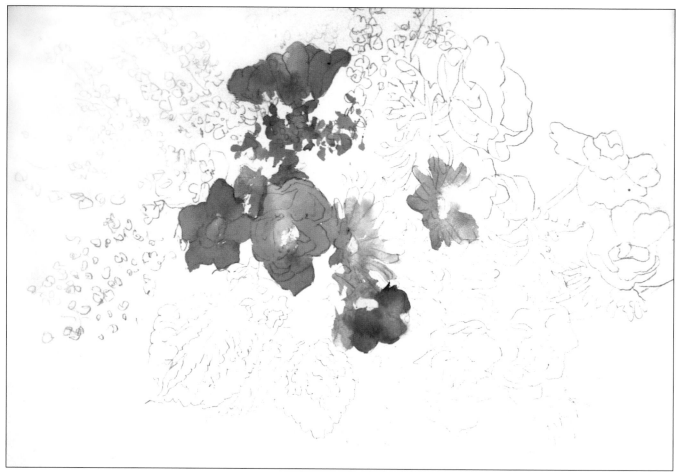

STEP THREE

Create Drawing and Begin to Paint

Use a no. 2 pencil to create a careful drawing on a half-sheet of 140-lb. (300gsm) Arches cold-press paper. This gives you the confidence and freedom to use the medium in a direct manner. You have the option to paint outside the lines; the structure will still be alive. Draw the bouquet contour shape and indicate the individual flower shapes—big area before small area. Use the paper edges to interrupt and create additional shapes. Wash off the paper sizing with a sponge and when dry, begin the painting process. I don't stretch my paper. Use ample amounts of freshly-squeezed pigments with clean brushes and water. I used nos. 8, 12 and 14 pointed brushes for this work.

Work on the subject first, leaving the dark background until the end. Focus on an area where a group of flower shapes merge together. Light values of Permanent Alizarin Crimson, Winsor Red, Winsor Orange and New Gamboge come first. Try to keep the color clean, think analogous color and warm light, and don't go too dark, too soon.

The purple flower is next—French Ultramarine into Winsor Violet into Cobalt Violet into Permanent Rose. Merge surrounding color into shadow on the white daisy shapes. Aim for luminous light shadows and color unity.

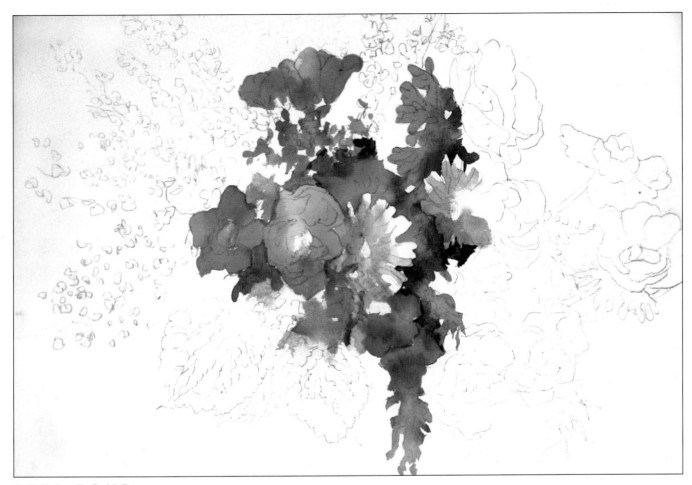

STEP FOUR

Establish a Stage With Color
Connect background foliage to establish a stage for the
flowers. Merge a light value of Winsor Green (Blue Shade)
mixed with New Gamboge, Burnt Sienna, Cobalt Violet
and French Ultramarine on dry paper. Charge some darker
value in while this is still moist. The pencil lines of individ-
ual stems and leaves can be seen through the mass of color.

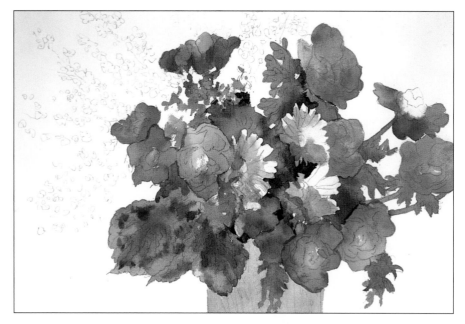

STEP FIVE

Expand and Reassess

Continue to expand the bouquet; think light value and clean color. Paint the cluster of coleus leaves with Winsor Green (Blue Shade) mixed with New Gamboge; merge Permanent Rose and Purple Madder and apply for accent. The careful drawing allows you to achieve the essence in a painterly manner. I'm not compelled to stay within the original pencil lines. The container is simply established to contain the bottom edge. Merge the right purple flower into its stem. Parts are interconnected and color-related for unity. Every painting reaches a point where you really wonder where you are going. For me, that stage is now! I've learned that it's best to stop, prop my work against a wall, step back, and look at what's happening from a distance. I immediately think some darker values will help at this stage.

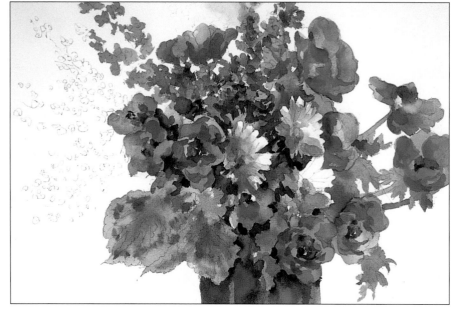

STEP SIX

Define and Refine

Define some petals of red and purple flowers by layering a middle value over the original light wash, making sure to leave some light edges for sparkle. Black centers can be color-exaggerated. Try French Ultramarine, Purple Madder, Winsor Blue (Green Shade), Winsor Green (Blue Shade) and Burnt Sienna for interest. A darker value layered over existing foliage area negatively defines a few stems and details and adds dimension.

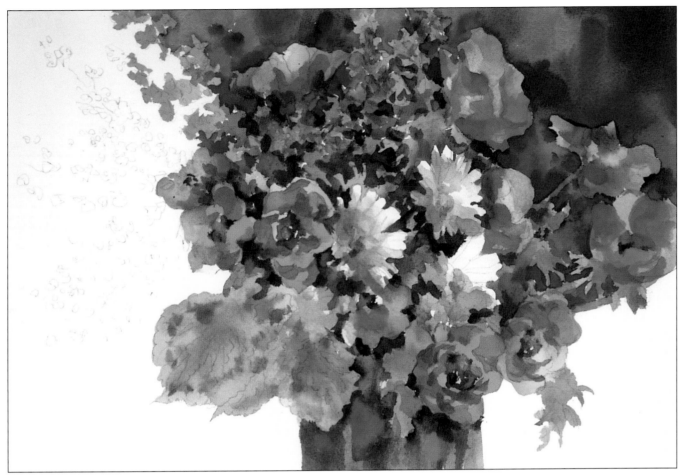

STEP SEVEN

Background

Now we're ready for the background! Fortunately, we have some contained edges, which allows for work in the upper right and center area. That's a manageable area to handle. Backgrounds are more difficult than subjects. With dry paper, begin laying in Cobalt Violet in the middle area, then charge in some pure French Ultramarine, then Winsor Violet mixed with French Ultramarine to suggest an added richness. Use a considerable amount of pigment and water on your brush. I like to find and lose edges as the background merges with the bouquet. The background should look alive, not pasted, so make the background value closer to some flower values and darker in other areas. It's important to lay it down and leave it alone.

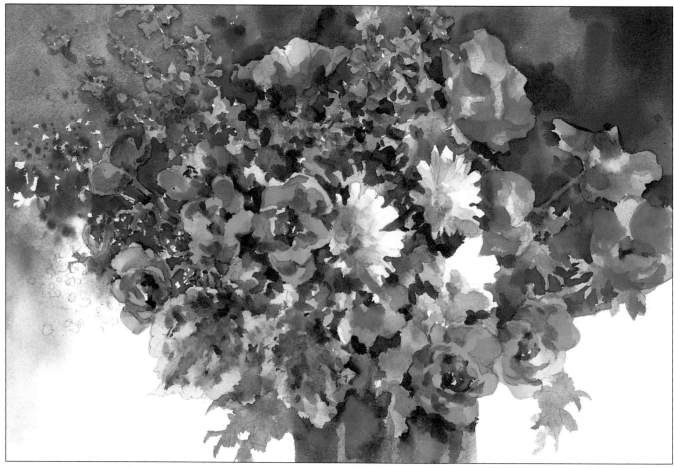

STEP EIGHT

Continue the Background

A suggestion of a complement: Add a bit of New Gamboge to Cobalt Violet to suggest a neutral, less intense color in the upper left corner. It's intentionally a lighter value to add variety. While wet, charge in some pure saturated French Ultramarine and paint around some of the baby's breath whites.

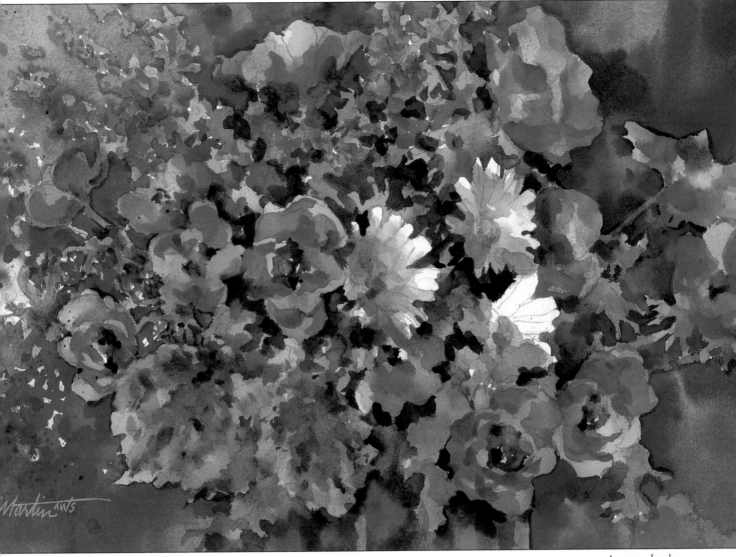

STEP NINE

Anemone Jewels
15" × 22"
38.1cm × 55.9cm

Finish

Continue the process in the right lower corner. I think the painting is finished. Check the big areas, the light and dark value relationships and the warm and cool color relationships. A few additional dark accents are added to make the color sparkle.

Exaggerate For Excitement

The creative part of painting is discovering a distinct approach. Dramatize! Reach for an imaginative and strong interpretation! First try the obvious; then explore a different way. Show your concept of drama through your choice of exaggeration. Determine the exaggeration by the way you wish to address the subject.

Exaggerate Color

Exaggerate

You've completed a painting presenting a subject in a conventional viewpoint. There are aspects you like about the painting—the subject, experience or spirit—but there just isn't any impact. Prop the piece up in your studio and ask yourself some questions. How can the content be expressed more imaginatively? Should the color be more expressive? Does it include too much material? Would an unusual detail be more dramatic? Should the primary interest be larger? Should the darks and lights have more contrast?

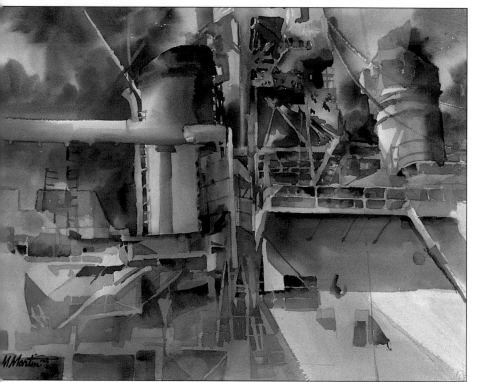

USS Little Rock
22″ × 30″
55.9cm × 76.2cm

Idea

I love the abstract shapes of many areas. Why not isolate and select a particular section, enlarge and create an explosion of vibrant color? The subject, a retired battleship, in reality has much detail and monotonous color.

Problem

How to isolate with so much detail?

Solution

Using a viewfinder, choose a small area and enlarge it to fill the paper. French Ultramarine is my mood, so I use it as the dominant color along with Burnt Sienna, Cobalt Violet and others for variety and warmth. Go beyond battleship gray!

Use different color combinations and compositions to create a series of abstractions. Try a creative approach by exaggerating the color and size.

Idea

It was while attending the annual St. Patrick's Day parade that I thought, "Why not paint the town green?" After all, green clothing, green food and green decorations were everywhere.

Problem

How to create interest and excitement in a one-color painting?

Solution

This is essentially a value painting. Every area begins with Winsor Green (Blue Shade), Winsor Yellow, New Gamboge, French Ultramarine, Winsor Blue (Green Shade), Cobalt Violet, Winsor Violet, Purple Madder, Burnt Umber and Burnt Sienna, mixed separately with Winsor Green to create warm and cool versions. Permanent Alizarin Crimson mixed with Winsor Green represents the darkest dark. Exaggeration of color presents a story and a unique statement.

Exaggerate Darks and Lights

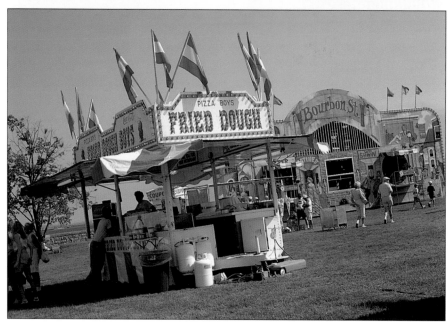

Problem

I was visually enchanted by the kaleido-scope and crescendo of rich color in this subject. These photos are a selection of many taken while spending a few morn-ings and afternoons absorbing this special ambience. How do I organize all this ac-tivity? I like it all!

Solution

I feel the darks and lights can be fabricated and exaggerated to create a unity. A nighttime atmosphere seems a dramatic possibility. Darks are exaggerated on the sides for containment, while light reflecting color radiates in the center sky area. Intense contrasts create a mood of mystery.

Carnival Theatrics
19″ × 27″
48.3cm × 68.9cm

Exaggerate Size

Crop to Exaggerate

Consider zooming in on imagery. Enlarge and make it the focus
of your painting. Use a viewfinder to discover possibilities. Mine
consists of two separate mat strips that can be adjusted to any
proportion. By moving the strips around, either on location or
on a photograph, you'll arrive at potential plans. Keep an open
mind to proportion and croppings—vertical, horizontal and
square are all possibilities; also, experiment with various eye lev-
els. Ordinary subject matter often creates more excitement when
moving in close, but you will probably need to have additional
detail reference.

In this case, the problem was to isolate, enlarge and position
the detail on the page in an exciting manner.

This eye level and perspective reflects my feelings best. A
straight-on view would not be as exciting. Consider exaggerat-
ing the size of your subject for a strong attitude and translation.

The Power and the Glory
22" × 35"
55.9cm × 89cm

Change the concept by exaggerating the size. The buildings will be showcased by exaggerating the smallness of the people. People of normal size create a more equal relationship with the buildings. Different sizes create different emphasis and new concepts.

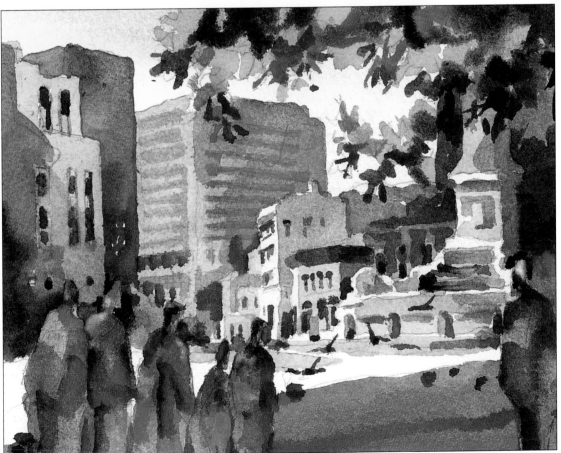

Exaggerate the Story

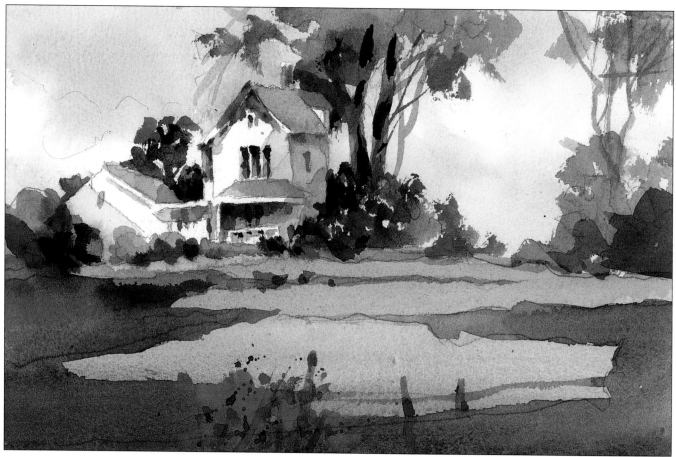

Idea
This 7½″ × 11″ (19.1cm × 28cm) quickie was a subject I encountered and painted on location. I gravitated to the white structure silhouette and surrounding space, but the problem was it could use a spark.

A More Exciting Way

The more you paint a subject, the more you discover and develop communication with that theme. Initial artificiality wears off, and depth and profoundness begin to set in. The more familiar you are with your subject, the more liberties you can create. There is always another (and sometimes more exciting) way to present your statement. Keep your options of selection open!

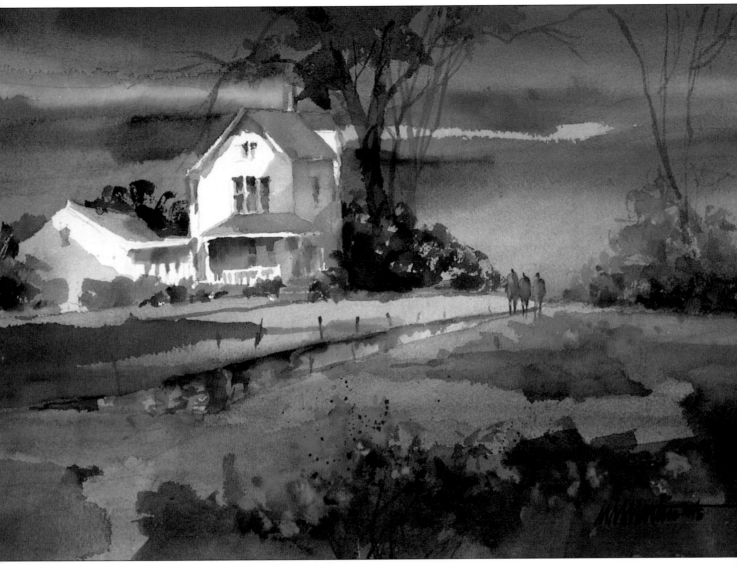

Solution

A dark, storm-like sky background behind the structure creates contrast and excitement. The indication of silhouetted people placed to intersect midground and background adds to the story. My story is transferred to you to interpret in your own way. This is one way to pull imagination into your statement. Let your ideas emerge!

The Storm Passes
15″ × 22″
38.1cm × 55.9cm

Exaggerate for Excitement

Autumn is a time for celebrating nature's bounty, suggesting a variety of colors, shapes and contrasts. The art of autumn in my studio environment—it's a colorful whirl!

The still life setup in this demonstration was one of many arrangements staged at my annual Fall Festival studio workshop. The flowers are harvested from my garden; the basket, crock jug, pine cones and shutter are part of my studio accoutrements; and the fruits are from a farmers market.

Unify the Composition
Check the relationship of positive to negative area by making a simplified contour drawing of the whole. Is each area an interesting shape? Does the positive area occupy the greatest space? Are the objects connected? If disjointed, now is the time to invent or exaggerate, perhaps by size of existing or additional objects.

STEP ONE

Exploration
Think of space—placing objects in front of or behind other objects when setting up an arrangement. Use objects you like. Think unity and group, rather than isolation or individual. Fall in love with your grandmother's vase, but find a way to have it connect with the other selections.

Create variety in the form of angles, such as the table perspective, basket placement and banana bunch. These suggest movement and create intimacy. Consider placing objects on various levels to create an interesting contour of heights.

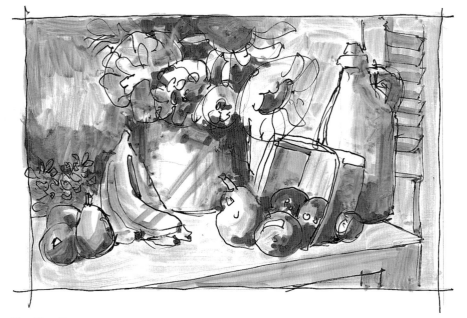

The First Response
The information and potential are here, but some punch and value organization could improve the statement.

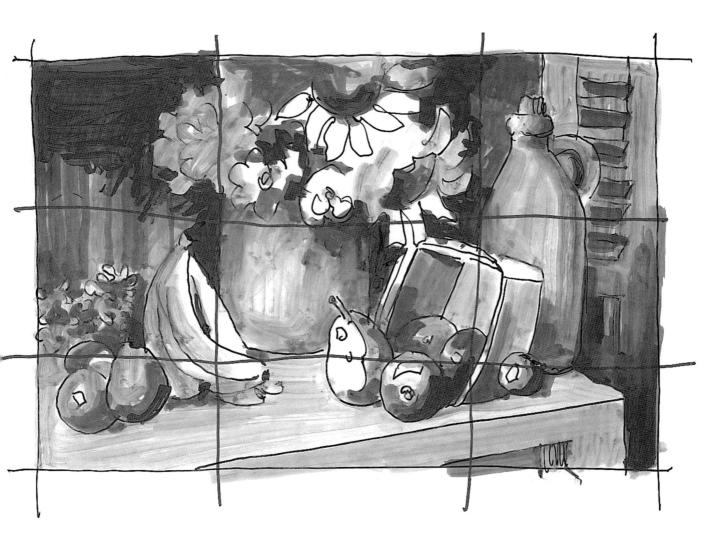

Exaggerate For Drama

Injection of dark value behind the setup will create snap, establish containment and organize the lights. This is one approach. Another attempt might be to keep a light background, but exaggerate and unify the darks of the objects. There are usually many possibilities.

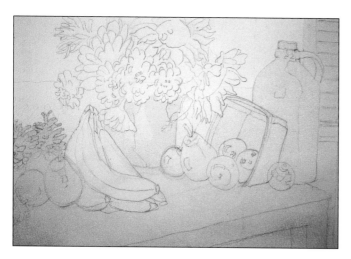

STEP TWO

Draw and Paint

Enlarge and transfer the value sketch onto Arches 140-lb. (300gsm) cold-press watercolor paper. Check the arrangement again, because it's not unusual to require additional adjustments (additions and/or deletions).

Keep in mind that less color layers translate to more clean color. With dry paper, begin with a light warm value mixture of Rose Madder and Winsor Yellow. Using a 1½-inch (4cm) flat brush, attack a large abstract area, keeping the background and flower areas untouched, allowing the white paper to show fresh, vibrant color. Masses come before objects at this stage.

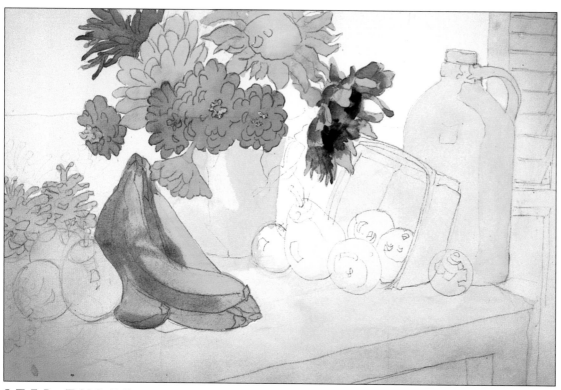

STEP THREE

While palette, pigment and water are clean, suggest the light values of the flowers. Using a no. 8 pointed brush, merge Permanent Rose, Winsor Red and Winsor Orange for one group, and New Gamboge and Winsor Yellow for the other. Exaggerate this value so it is lighter than you imagine. It's so easy to hit the middle value first, losing the lights.

Lay a light value of Winsor Yellow and New Gamboge over the banana bunch with a touch of Rose Madder to reflect the nearby flower color. Exaggerate even if you don't see it! Merge a light cool tone of Cerulean and Cobalt

Violet wet-into-wet. Let dry! Exaggerate the neutralized banana shadow tone to reduce the size and shape dominance.

Where's this going? Let's jump ahead and suggest additional values and colors of the primary sunflower. The center appears·black, but for more excitement, begin with a touch of Winsor Orange followed by Winsor Red, Winsor Blue, Winsor Green, Cobalt Violet and Purple Madder. While wet, use a brush and clean water to gently pull color out, suggesting shadows on petals. Find and lose edges of center into petals. Think value relationships!

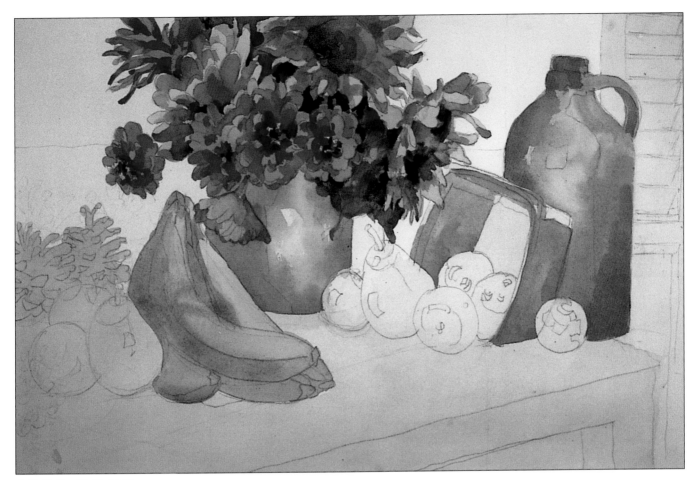

STEP FOUR

Squint, and treat the leaves as a mass of Winsor Green mixed with New Gamboge, Burnt Sienna, Cobalt Violet and French Ultramarine. Go for middle value indication of flowers. The major petal shadows are drawn on the paper, and the pencil lines continue to be visible, so act with authority. Connect the crock shape to the fruit. Find ways to link objects as you progress. Merge Cobalt Violet, Winsor Orange, Burnt Sienna and Rose Madder to indicate the basket and jug shapes.

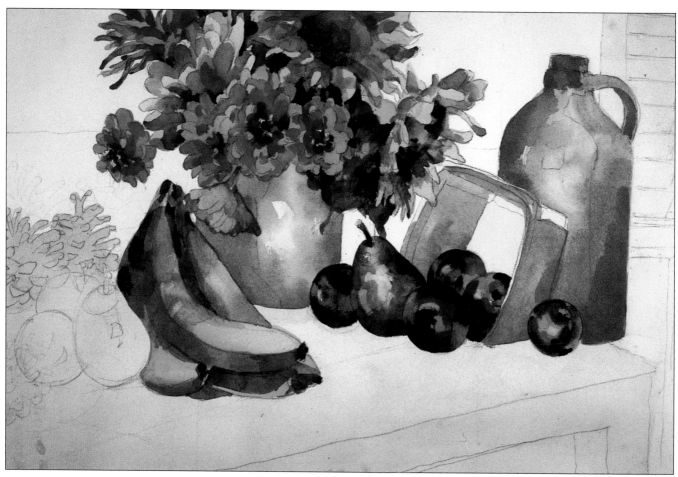

STEP FIVE

Exaggerate the plum colors. On dry paper, apply a light value of Permanent Alizarin Crimson, then merge Cobalt Violet, Purple Madder, French Ultramarine and pure Winsor Blue and Winsor Green. While damp, charge in a dark value of Purple Madder and French Ultramarine mixture. Saturate your no. 8 pointed brush with pigment. Too much water creates many layers of paint and a loss of transparency. For the pear, begin with Winsor Yellow and New Gamboge and merge with Winsor Green followed by Burnt Sienna for a medium warm value, then French Ultramarine and Winsor Green for a dark cool value. Rose Madder and Purple Madder are the last to be combined. Leave alone to dry.

Glaze additional banana shadows with Winsor Blue, Cobalt Violet, Winsor Orange, Winsor Green and Cerulean Blue.

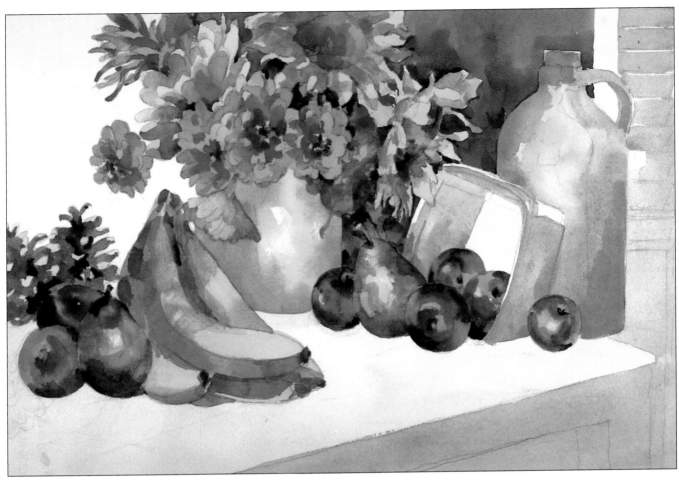

STEP SIX

Define the pine cones with a darker value. Paint the negative area so the light highlights, originally drawn in pencil, remain. Approach the left side of the fruit in the same manner as on the right. Establish ways, through value relationships, to discover edges and to lose them. Allow the eye to move in and out by opening a pathway between each fruit. A value similarity between an edge of the pear and the bananas allows the eye to move from one fruit to the other. The edge is rediscovered by value at the bottom edge of the pear. Exaggerate the pathways. The plum color is exaggerated by emphasizing French Ultramarine. The highlight value is exaggerated by making it lighter.

In one sweep, using a 1¼-inch (3cm) wide flat brush, connect shutter shape to the area beneath the table with a mixture of Winsor Green, Cobalt Violet and Cerulean Blue. View this as an abstract shape.

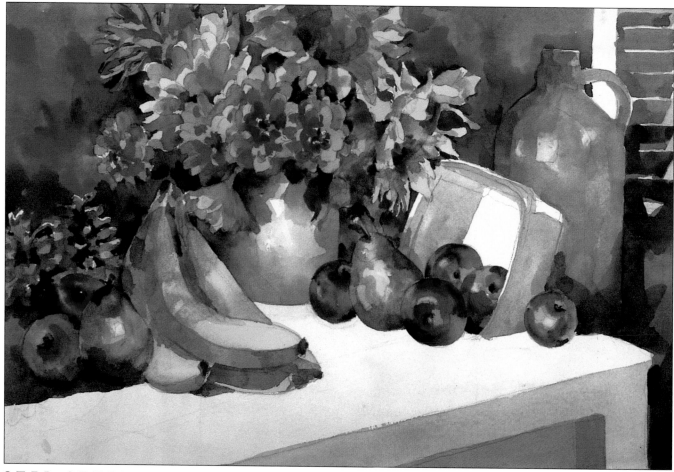

STEP SEVEN

Lay in the remaining background shape using similar colors. Refer to your value sketch for contrast suggestion and guidance. Sometimes value adjustments need to be made. The final decision needs to be relative to what is happening on your watercolor paper.

A dark value needs to be indicated behind the jug for balance. Purple Madder, Burnt Umber and French Ultramarine are my color selections.

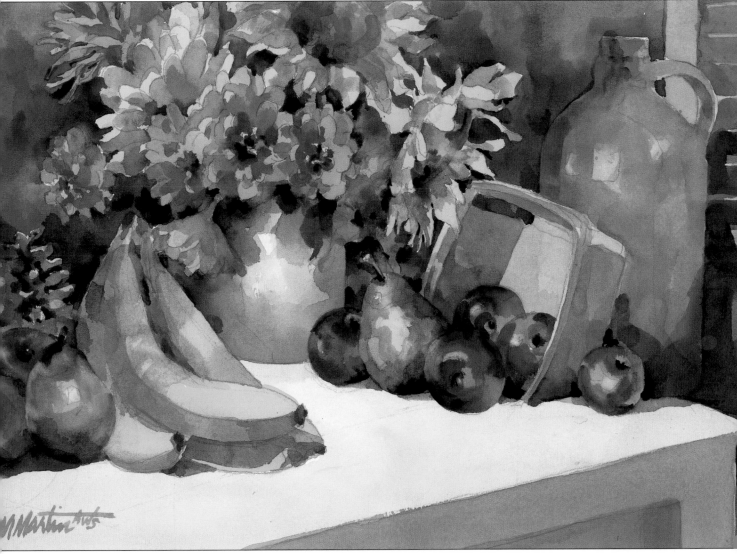

STEP EIGHT

I want to take a look at this in the morning with fresh eyes. All my energy has been given so far, and I'm exhausted! It's a good exhaustion, however! Time away will provide fresh thinking.

The following morning I add a few dark accents around the flowers, along with some shadows and value adjustments in the basket. I decide to exaggerate the tabletop value, making it lighter than the value sketch. The extreme contrast will lend drama and watercolor sparkle.

Fall Festival Workshop
15" × 22"
38.1cm × 55.9cm

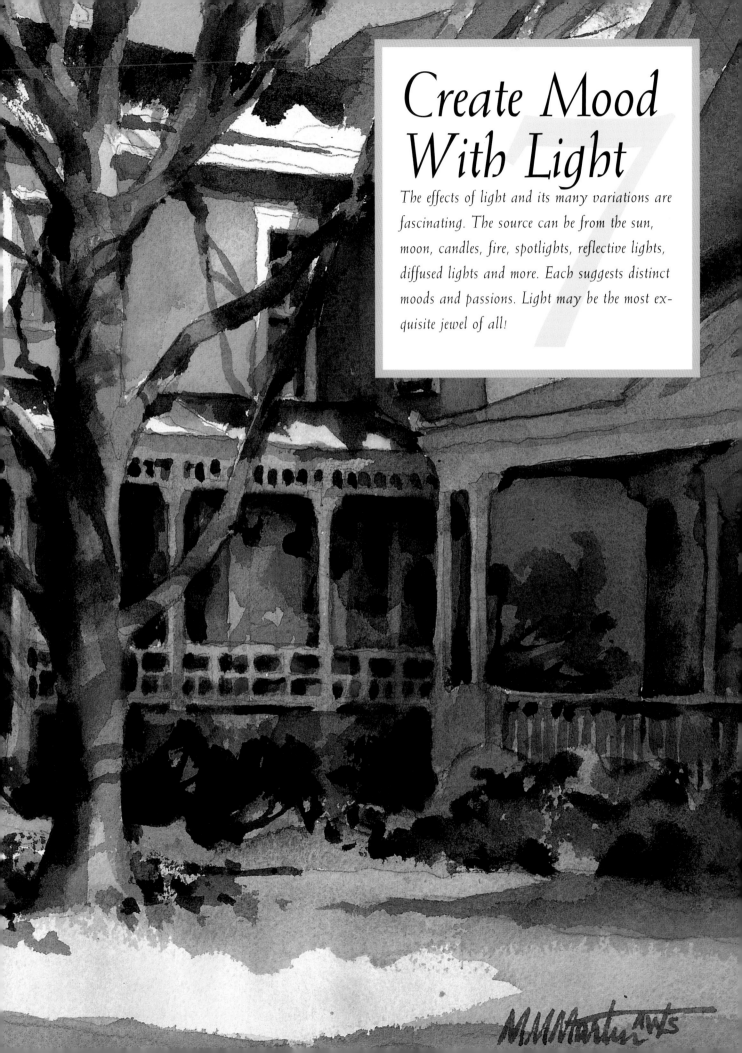

Create Mood With Light

The effects of light and its many variations are fascinating. The source can be from the sun, moon, candles, fire, spotlights, reflective lights, diffused lights and more. Each suggests distinct moods and passions. Light may be the most exquisite jewel of all!

How to Create Light

Even though painting is an emotional process, there is a science to light. We need to think of light as reflected from different surfaces and from different angles.

Know the location of your light source. It can come from the back, front, side, overhead or in-between. Natural and artificial light hits a subject and casts a shadow. Shadows are the anatomy and dimension of light, providing unity and luminosity and defining form and subject.

In transparent watercolor, light also comes from the paper. Clouds of color on white watercolor paper bounce brilliance from the paper. This brilliance translates to a particular quality of light. Seek pathways of continuous light to weave throughout your painting. These pathways allow dark patterns to unify and interlock. Try to overcome an instinct to individualize. Paint the feel and movement of light on objects, not the objects themselves.

Light Qualities

- Color, both warm and cool
- Value
- Luminosity
- Patterns
- Volume

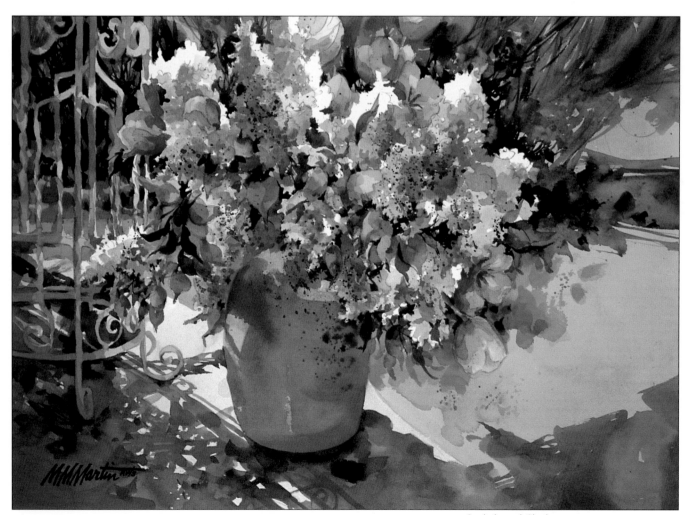

Backlighting

Squint, and you'll realize that backlighting reduces a subject to a dramatic silhouette in shadow with limited detail. The light source here is primarily behind the subject with front cast shadows providing containment and unity.

Sunlight and Shadows
22″ × 30″
38.1cm × 76.2cm
National Taiwan Art Institute Collection

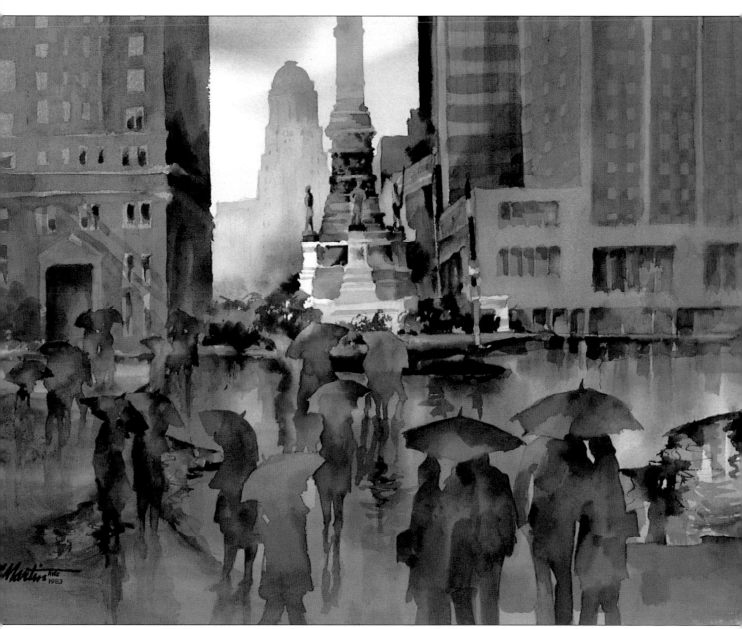

Light Can Create Atmosphere
Weather conditions determine an aura. There's beauty and quiet dignity in a soft rain.
Warm light is diffused, and warm and cool colors are limited. The natural light source
is from above with reflective light cast on the wet pavement. Value relationships are
important.

Rainy Day—
Downtown Buffalo
22" × 30"
38.1cm × 76.2cm

Think Light

An artist must first look and see, then comprehend the phe-

nomena of light. This is not a superficial process; it takes

time and concentration. Know your craft. Build the ability

to perceive by motivating all your senses and intellect. It

takes mental energy and emotion.

Light Moods

The time of day creates different light quality. Morning and late afternoon often demonstrate a dimensional light. Noon suggests a flatter version. Night, of course, shows limited light but also a mood of mystery. You might ignore a subject at one time of day, but discover its radiance of light at another time.

Seasons of the year also present different possibilities. In fact, you might try a similar subject and indicate an appropriate light mood for each of the four seasons.

Commissions or Not?

The two nighttime paintings on page 117 were part of a commission project to celebrate the one-hundredth anniversary of the Lancaster Opera House. Whether you choose to accept commission assignments or not, consider the opportunity. I know from experience that it's easy to become involved in situations beyond one's capabilities and experiences. Accept the fact that you can't be master of every vision. This project was involved, and research time was necessary, but I learned a bit of theater history in the process. I also gained an added appreciation and knowledge of nighttime light.

Taxco Light
22" × 30"
55.9cm × 76.2cm

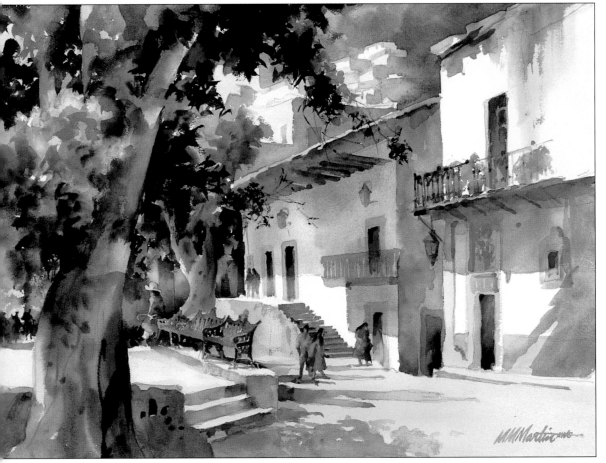

Environment of Light

The quality of light varies in different parts of the world. The sharp light of a sunny day that I'm accustomed to in the Great Lakes region contrasts with the sun-drenched light of Mexico. This is late afternoon light; the source is from the left. The building shadows show color luminosity but are the same value. Aim to have the cast shadows adhered to the wall, not stuck on or pasted!

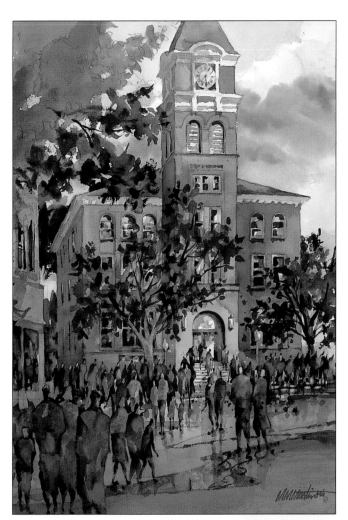

The Light of Dusk

I have always been enticed with the mood of descending dusk. There is a wonder and a mystery, an especially beautiful and quiet time. First, observe and compare the value relationship of the structure to the sky. Suggest the warm glow of twilight in the lighter sky. The most glowing, warm color is located most closely to the primary artificial light focus. The silhouetted crowd is designed to gravitate to the warm light, which leads to expectation and enrichment inside.

Curtain Up
29″ × 22″
73.7cm × 55.9cm
Lancaster Opera House Collection

Indoor Light

Interior light presents a unique mood. Obviously, the intense artificial warm spotlight is focused on the stage, but it's the mystery of the reflected light and subtle nuances away from the focus that I find intriguing. Get some color into the surrounding darks to achieve luminosity in the light. Dark doesn't need to be translated as black. In this case, dark contains light. The performers reflect the repertoire of entertainment, not particular individuals. A salute to the performers and a salute to the artistry of light, value and color!

Show Time
22″ × 30″
55.9cm × 76.2cm
Lancaster Opera House Collection

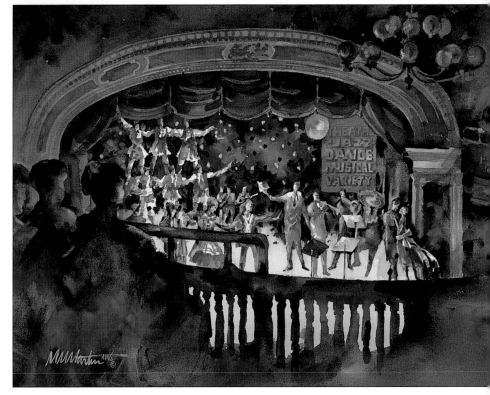

Luminosity

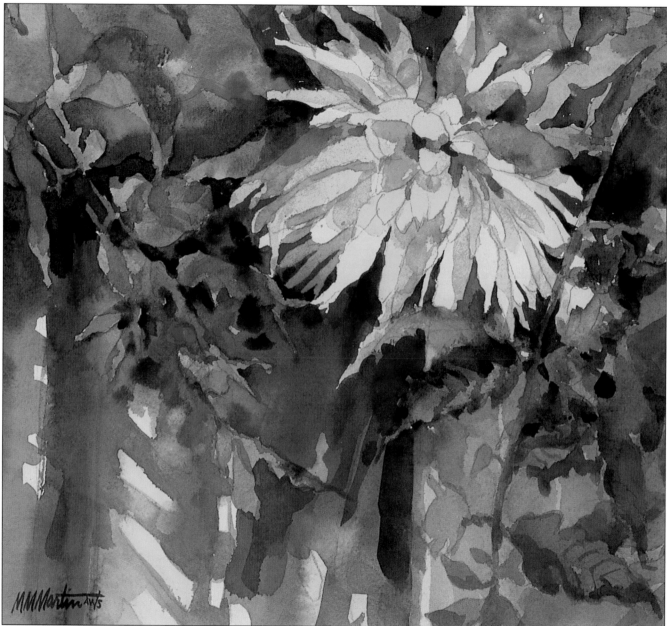

Cast shadows dramatize vibrant light. This indoor setup was included in my Fall Festival studio workshop. Afternoon sunlight cascaded through venetian blinds, casting unusual shapes on the fabric and objects. Take advantage of immediate happenings!

Fall Festival Theatre
14½" × 15½"
36.8cm × 39.4cm

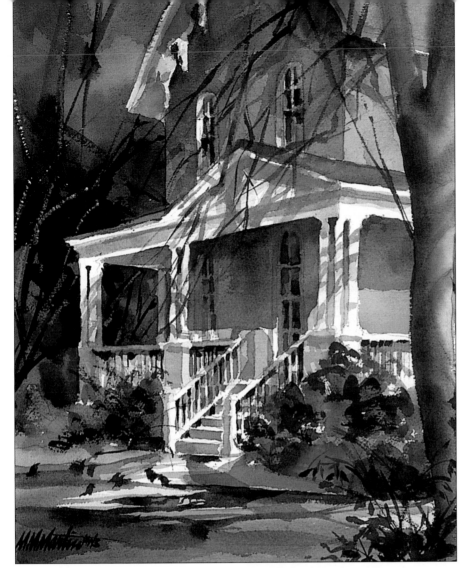

The warm shadows show off the instantaneous, luminous morning light. Light is only light where there are darker areas to be compared. Fresh, clean color in the lights and darks helps to create luminosity. I feel the immediate moment was captured. It will never be quite like that again.

A Sparkling Moment
16½" × 13½"
41.9cm × 34.3cm

Like a mirror, the sky is reflected in the water, creating a luminescent quality. A pattern of light weaves throughout the mass, inventing connections. Luminosity has a lot to do with directness—knowing the intensity of value and colors and laying them down correctly the first time, or at least the second time! A value sketch is the key.

Gathering of the Clan
22" × 30"
55.9cm × 76.2cm

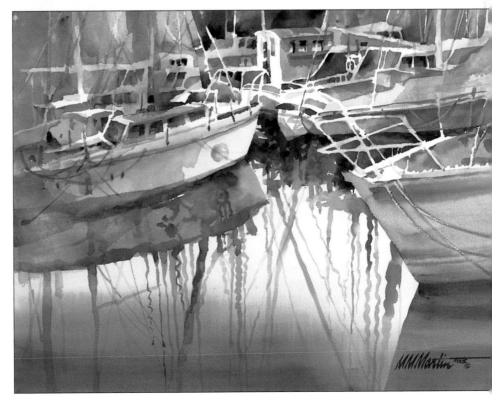

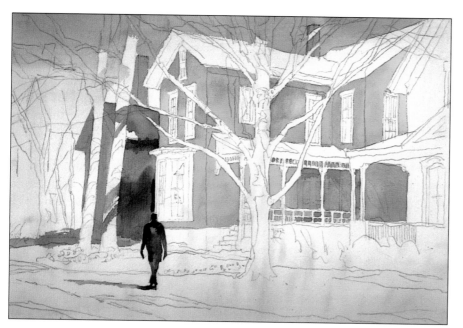

STEP FOUR

Clean water and clean color are a must. Exaggerate the warm light on red brick by laying in a mixture of New Gamboge and Winsor Orange over the entire area. This is the lightest value. At this time, indicate cool tones of a similar value under the porch. Winsor Green (Blue Shade) and Permanent Alizarin Crimson are good choices. Aim for color saturation as well as transparency. Keep in mind that it will dry lighter and that the wash should lay on the sides of the structure. It's not pasted on.

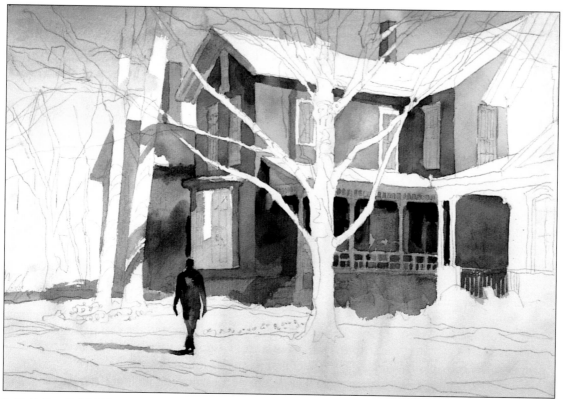

STEP FIVE

Return to the value sketch to fully understand the big shadow areas of the front and side of the building. Mix Purple Madder, Winsor Green (Blue Shade) with Permanent Alizarin Crimson and glaze over the existing color. Connect one side to the other in one action. Think abstract! Make the wash transparent so that when dry, the initial color glow shows. This is one way to show light in transparent watercolor. Whites in shadows are sometimes darker than you anticipate. Eliminate the whites of the window areas in shadows as well as some of the white porch trim. Use Winsor Blue, Burnt Sienna and a touch of New Gamboge for warmth.

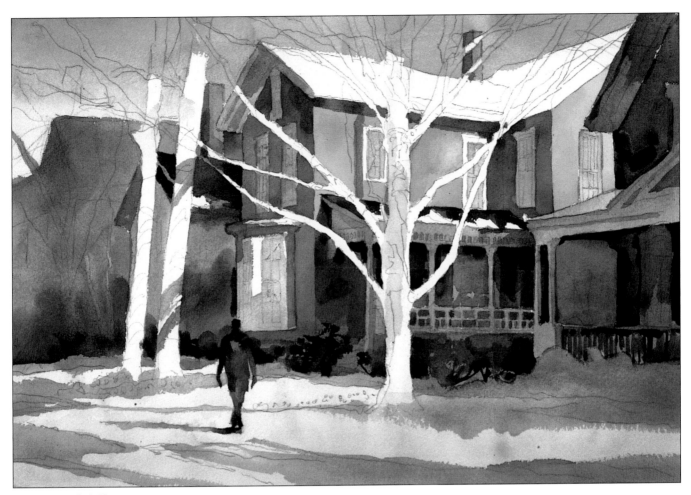

STEP SIX

Think of shadow as harmony and light as variety. Use harmony to orchestrate how the eye flows across the paper, while retaining the variety to hold the eye around the focal point. While constantly comparing shadow values to adjacent areas, eliminate the white area around the focus with Winsor Blue, Burnt Umber, Purple Madder and Cobalt Violet. Color variety in a similar value can be invigorating and breathe life.

Indicate shadows in the foreground snow. Remember that surrounding color is reflected. Respond to your impulses as well.

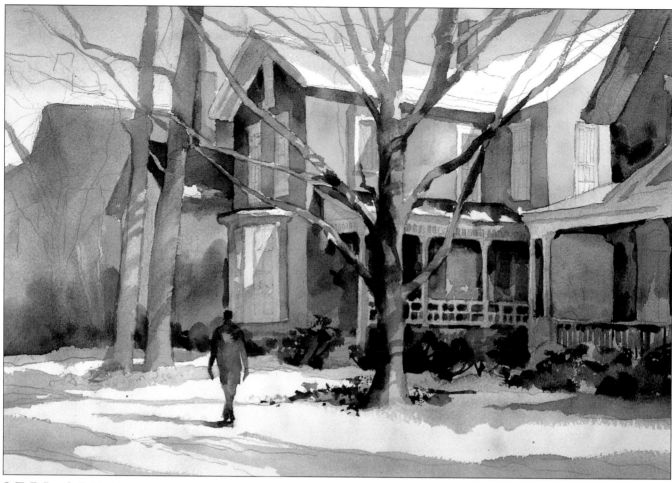

STEP SEVEN

Let's make the trees part of the mood. They've been left untouched in order to show luminosity and light at the finish. Start by using a light value of Winsor Orange and Permanent Alizarin Crimson to dramatize the light, merge a bit of Winsor Green to complement, followed by some rich dark shadows of Winsor Blue, Burnt Umber and Purple Madder. Let the colors diffuse. Keep the darkest dark near the emphasis, and suggest the extended branches in a lighter value. Take artistic license with the twin trees, eliminating some of the darks to avoid taking emphasis from the jewel-like light.

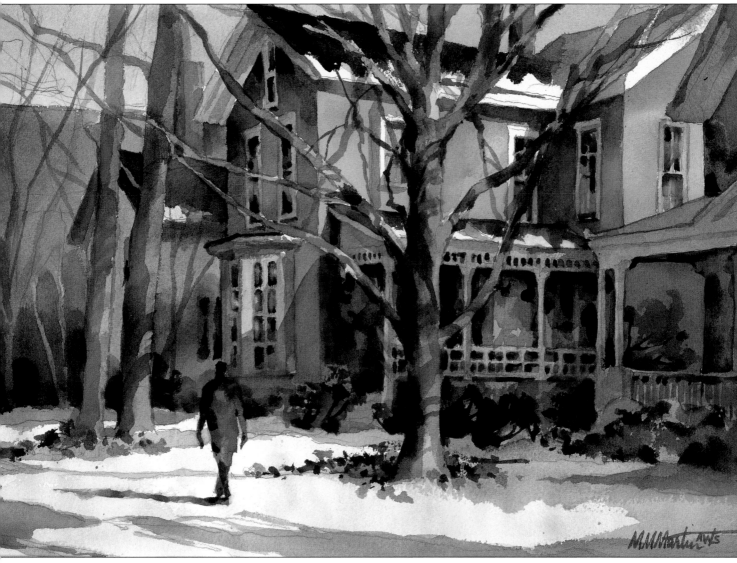

STEP EIGHT

Add dark value touches to finish—roof area, window panes and adjustments to foreground shadows. Step back from the work. Look and contemplate. I realize that light varies in every environment. In my region, I'm very attracted to the particular warm sunlight in February, contrasted with the colder temperatures.

I feel we've captured a feeling of intimacy and drama here. I emphasize that it wasn't the objects that made me want to paint this subject. It was the relationships of light to dark and warm to cool.

Consider painting a series in your environment, using light that attracts you at a particular time of year. Choose a subject that interests you, open your eyes, and communicate a total experience. Dig in!

February Sunlight
15" × 22"
38.1cm × 55.9cm

Conclusion

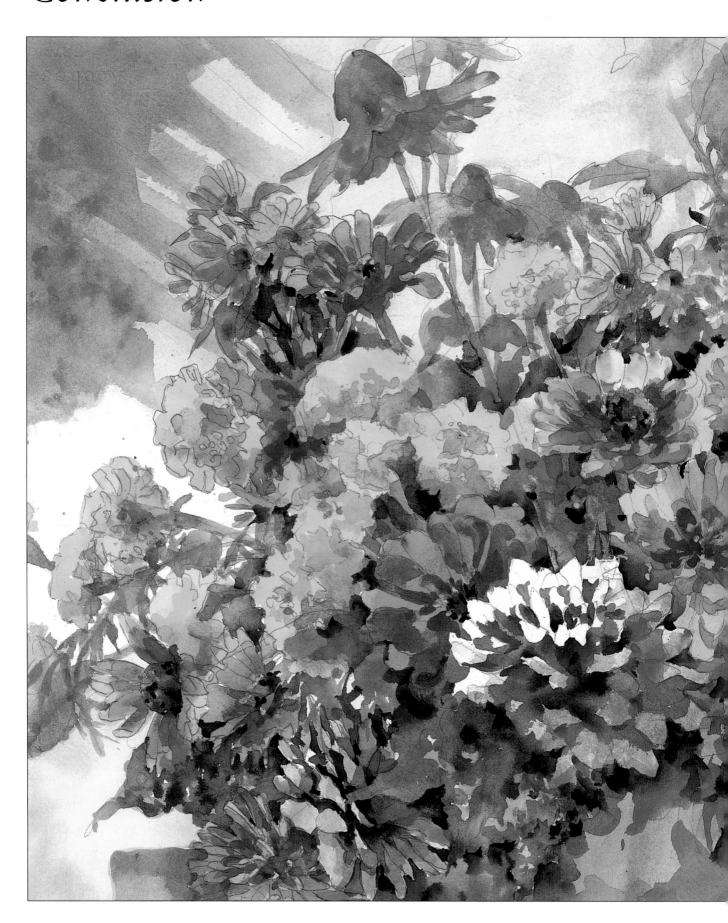

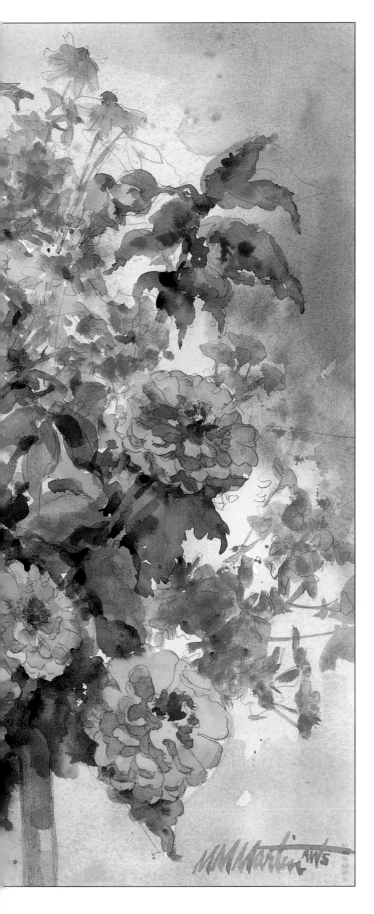

Step back every once in a while and take an honest look at your work. Keep one of your best paintings around to compare with what you're into now. Enjoy the highs of your successes and find ways to make positives out of your failures—that next painting can be the best you've ever created. Always put your work ahead of yourself, not vice versa.

Learn the craftsmanship, then weave all your experiences into your work. Creating art is an attitude and a special vehicle that allows you to be a unique, visual communicator. Paint your world, give it the best you have, and you can't lose. Make every painting a new adventure and a celebration of a vital way of life!

- Know yourself.
- Take time to cultivate discipline in seeing.
- Learn independence and self-reliance.
- Focus and work continuously.
- Pursue and surround yourself with excellence.

Just as there are a variety of art worlds, there are many watercolor worlds. Transparent is one way; certainly it's not the only approach, but it's an avenue I love. The action and vitality are for me, and I'm still learning!

Country Garden
22″ × 30″
55.9cm × 76.2cm

Index

A

Allen Street Design, 72
Allentown Glow, 83
Anemone Jewels, 93
Atmosphere, and light, about, 115

B

Bright and Beautiful, 15
Brushes, choosing, 12

C

Carnival Theatrics, 99
Carnival Theatrics II, 33
Center of interest, highlighting the,
 32-35
Classic Beauty, 53
Color
 analogous, 74, 76
 and value, relating, 72-73, 77
 complementary, 74, 76, 78
 exaggerating, 96-97
 fundamentals, 74
 saturation, exploring, 77
 seeing, 76-77
 temperature, 73, 78-79
 using, to create drama, 71-93
Color chip chart, creating a, 75
Colors
 blending, 80-81
 choosing, 13
 planning, 86-93
Color wheel, explained, 74
Country Garden, 127
Crescendo, 29
Curtain Up, 117

D

Darks
 exaggerating, 98-99
 luminous, creating, 81
Distinctively Franklin Street, 9
Drama, creating
 with color, 71-93
 with value, 45-69
Drama, exaggerating for, 105
Drawings, creating, 84, 120
 See also Sketches, creating

E

Edges, types of, 21

F

Fall Festival Theatre, 118
Fall Festival Workshop, 111
Family Gathering, 56
February Sunlight, 125
Feel of New Mexico, The, 52

Flamboyant, 61
Forms, positive, placing, 24
 See also Space, positive and negative

G

Gala Splash, 61
Gathering of the Clan, 119

I

Idea, exaggerating the, 102-103
Iris Complements, 78

L

Leading Lady, 27
Light
 creating, 114-115
 qualities of, 114, 116
Lights, exaggerating, 98-99
Light, using, to create mood, 113-125
Luminosity, about, 118-119

M

Marina Design, 30
Markers, for sketching, 14
Mood, creating, 60-61, 99
 with color, 72-73
 with light, 113-125
Morning in the Park, A, 43

N

Nautical Design, 83

P

Painting the Town Green, 97
Palette, using a, 13, 53
Paper
 choosing, 12
 edges, using, 28-30
Photos, reference, using, 14, 36-37, 120
Pigments, transparent staining, using, 74
Port Patterns, 34
Positively Fiesta, 73
Power and the Glory, The, 100

Q

Queen of the Lakes, 25

R

Rainy Day–Downtown Buffalo, 115
Regal Rulers, 57
Royal Dazzle, 32

S

Shadows, cast, using, 32-33, 121
Show Time, 117
Signature Design, 26
Size, exaggerating, 100-101
Sketchbook, using a, 14

Sketches, creating, 120
 See also Drawings, creating; Value
 sketch, building a
Space
 creating, with value, 58, 64
 illusion of, creating the, 37, 46
Space and Place, A, 59
Space, positive and negative, using, 26,
 30-31
 See also Forms, positive, placing
Sparkling Moment, A, 119
Sponges, using, 14
Springtime Flourish, 13
Storm Passes, The, 103
Strokes, practicing, 20
Studio Sunlight and Shadow, 60
Sunlight and Shadows, 114
Sunset, 31

T

Taxco Light, 116
Techniques
 edges, 21
 strokes, 20
 washes, 18-19
Timeless Irish Tradition, A, 57
Tones, neutral, using, 82-83
Too Handsome to Forget, 51

U

Unity, creating, 24, 33, 39, 90
 with color, 80, 90
 compositional, 104
 with shadows, 65
Urban Drama, 35
Urban Sparkle, 24
USS Little Rock, 96

V

Value
 seeing, 46-47
 white paper, using, 56-57
Value chart, making a, 48
Values, identifying, 49-50, 54-55
Value sketch, building a, 37, 49-52, 54-
 55, 63, 120
Value, using
 to create drama, 45-69
 to create mood, 60-61
 to create space, 58, 64
Victorian Mystery, 55

W

Washes, types of, 18-19
World Unto Itself, A, 69